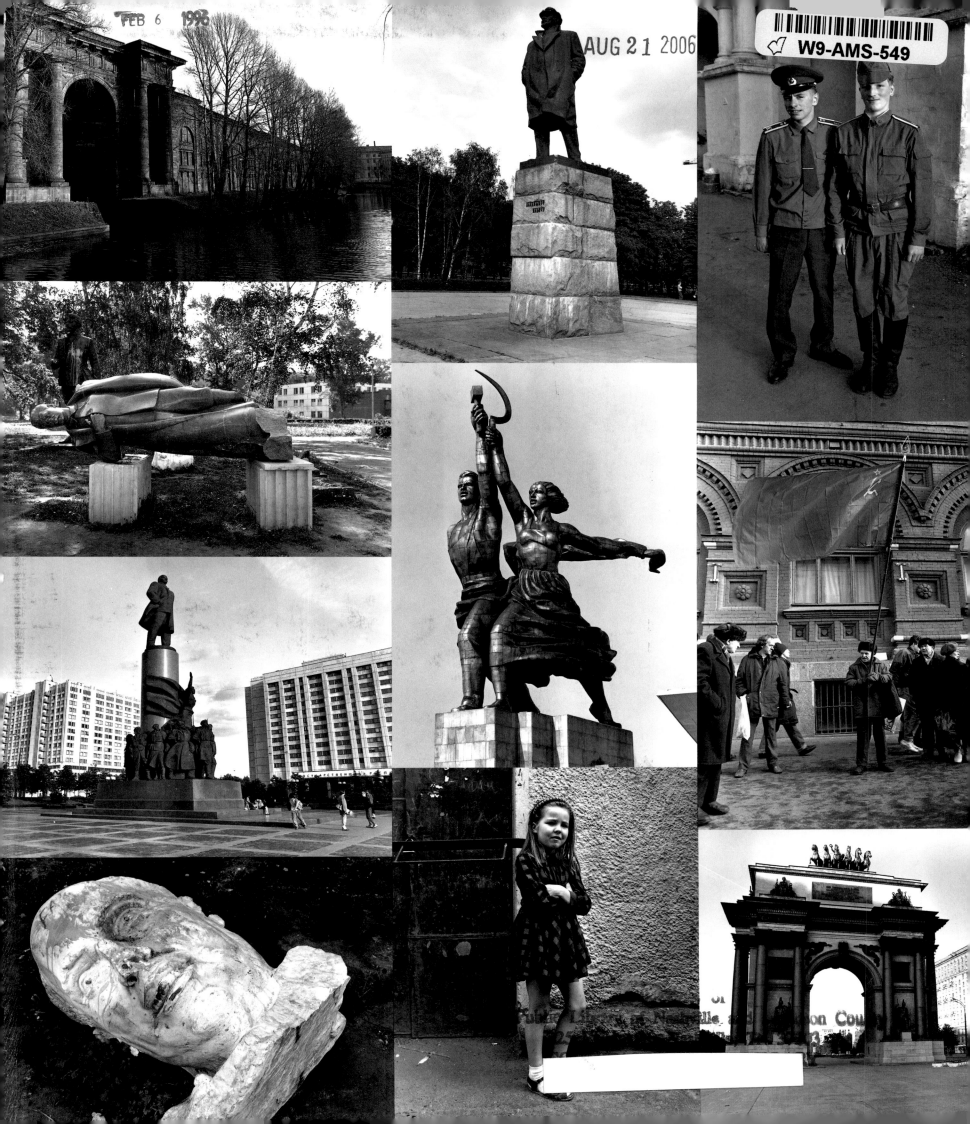

игра - форма свободы
него самовыражения
человека, которая при
сполагает реальную пр
открытость миру. Воз
можность ее разверты
вается либо в виде со
стязания, либо в виде
представления числа
лиц, к.-л. ситуации, Не
ля ряд связей числ. Не
или ряд связей числ. м
напряжений сопр. м

игра - форма свобода
ник.-л. ситуации, Не
стижение и виде со
или ряд связей числ
представление числа
можнность ее разверты
вается либо в виде со
сполагает реальную пр
него самовыражения
игра - форма свобода

New Russian Art

Paintings from the Christian Keesee Collection

Published by Curatorial Assistance, Inc.

Texts, Essays ©Copyright 1994 Project for Contemporary Russian Art

Photographs ©Copyright 1994 Jon Burris

Statement by Timur Novikov courtesy Paul Judelson Arts, New York
©Copyright 1993, Avant Garde, Moscow

©Copyright 1988 Sebastain Kuserberg, photo page 36

Editor/Designer: Jon Burris

Production: Karen Bowers

Printed in Hong Kong

ISBN 0-9628222-1-3

Library of Congress Catalog 94-068619

Contents

Foreword Christian Keesee

Devotion to art in its many forms has always been a Russian characteristic. If nothing else, we recognize the Bolshoi Ballet and the Hermitage Museum as two great institutions of fine art and civilization in the world. I was introduced to both during my first journey in 1988 to what was then the Soviet Union.

I was accompanying a group of businessmen from Oklahoma under the auspices of the People to People Exchange Program. Even though Gorbachev was in power and change in Russia was under way, our group's goal of initiating business seemed virtually unachievable. I had almost become reconciled to the daily guided tours that pointed out the "superior Russian Olympic headquarters" and "the superior Russian monument to the superior Russian space program" when I decided to escape for a few days to see museums such as the Tretiakov Gallery in Moscow and the Hermitage in St. Petersburg. Both of these great institutions house incredible collections of art. Catherine II amassed one of the most impressive collections of Rembrandt in all of Eastern Europe, and recently uncovered works by Picasso, Braque, Matisse, and Cézanne shed light on the determination of other Russian collectors to bring to their country canvases by the world's master painters.

At the Hermitage I was able to see how, in the face of decades of adversity, art had been held in the highest regard by the Russian people. What was once the Winter Palace of the Czars—which had become little more than a shell after World War II—had been carefully restored to its original aristocratic state even under the oppressive doctrines of Communism. Today the museum attracts thousands of visitors every week, mostly Russian and some, I am told, who travel for days and spend a month's earnings just to see the collections. Unfortunately, over successive trips, I found that the dire economic situation that currently exists prevents much needed maintenance and updating of these facilities, and they are now reaching out for worldwide assistance. I have no doubt, however, that the spirit and ingenuity of the Russian people will prevail once again and they will find a solution to these problems in order to preserve their art.

At the end of my first trip, I decided I wanted to somehow make Russia a part of my life. I returned in 1990 on a short trip to visit the museums and galleries, tour the ruins of pre-revolutionary palaces, and decide on a course of action for long-term involvement. I knew I wanted to encourage friendships I had begun and place myself in a position to meet and work with other Russian people. I also felt I would like to become active with those associated with the post-glasnost art scene.

Their energy and optimism in the face of their own personal struggles was encouraging. At one point I even considered opening a gallery in the United States which would feature this new generation of Russian artists. I finally decided that I could share my fascination with contemporary art through the organization of a collection that would travel to museums in the United States and thus reach a broader audience. By purchasing the work of the contemporary Russian artists and exposing it to the public, I could achieve the same goals.

The group of paintings that comprise my collection to date represent the results of nearly three years of research and association with artists, critics, collectors, and dealers which began in early 1992. I first discussed the idea of a collection with Christopher Youngs, who was the director of the Oklahoma City Art Museum at the time, and together we met with free-lance curator Jon Burris, who had some experience in dealing with East European artists. Although we agreed to look at a variety of work, we did set certain parameters. We felt in general that we should avoid art that was overtly political, as it could easily become dated and often didn't translate well for Western audiences. In beginning our research, we found very little in the way of catalogs and practically no monographs on contemporary Russian artists. What we did obtain came mostly from the few shows presented by American galleries that represented émigré artists. For many reasons, their work seemed to be contrived and to belong to the past, and I suspected that artists who had chosen to remain in their country while it underwent extreme change would undoubtedly produce more engaging art. While I am aware that many contemporary

Christian Keesee, Trochprudnii Lane, Moscow, 1992

Russian artists deal with conceptual art involving installations and performances, I personally feel painting communicates more immediately and certainly in the context of a traveling exhibition.

In June of 1992, Jon Burris and I made the first of what would become three extensive trips to Moscow and St. Petersburg. We found early on that these cities have become the centers of activity for artists from all over the former USSR, mostly out of the necessity to have their work seen in the galleries that are opening there. In all, we would meet with more than a hundred artists and eventually arrive at a selection of 33. I would be remiss if I didn't mention two important individuals, Tania and Natasha Kolodzei, who made this process much easier than it could have been. As mother and daughter, they are also two of Moscow's most important private collectors and entrepreneurs on the contemporary scene. We had heard that for those interested in art, all roads lead to the Kolodzeis' apartment on Leninsky Prospect. Over the course of our three trips, we shared many wonderful times and learned a lot about the intricacies of Russian art circles. There were also art dealers in both Moscow and the United States who arranged introductions, and to them we are equally grateful.

Although much has been written about the "official" and "unofficial" artists, the underground, nonconformists, or members of the "new vanguard," the artists themselves seem to be moving quickly beyond such identities. We found that lines once drawn between social and political camps are blurring, and a distinctly competitive mood has replaced one of paranoia as, for the first time, the artists have been faced with the prospect of integrating themselves into a global marketplace.

Without the fear of reprisals and given the ability to communicate freely with an audience, it has become for these artists a wonderful time of experimentation with both ideas and styles. They also draw upon their rich cultural heritage and appreciation of all the arts while exhibiting a clear understanding of international trends and movements of the past decade. While the majority of the paintings in this collection are figurative, the influence of Constructivism, Neo-Expressionism, Primitive Expressionism, Hyperrealism, Pop, Conceptual, and Abstract art is to be found throughout the work. Irony, lyricism, and fantasy are recurring motifs, and there is a definite tone of subversive humor that runs through much of it.

One of the great benefits of a project such as this is the opportunity one has to meet a wide variety of people, from members of the officious Moscow Critics Union to curators in obscure wings of the Hermitage. Some of our best evenings were spent in lively conversation with them and were always accompanied by tea and vodka. Yet it is the artists themselves whom I will remember the most. It would be impossible to look at any given painting in the collection and not be reminded of the circumstances of acquiring it. Through interviews, we were able to learn about the details of the artists' lives which are inextricably a part of their work.

As I write this, I realize that day-to-day life in Russia seems to be in an ever-changing state of chaos, and one might wonder about the future of this latest generation of artists. I remain hopeful, however, believing their characteristic spirit will endure and that I may return again and again to witness the development of the new Russian art.

Assembling an exhibition like this requires the expertise of many people. I would like to express my sincere thanks to Jon Burris for his unending commitment to this project. Without his understanding and guidance, there would be no art here. His skills as curator, project coordinator, and documentary photographer have been integral to our success. Again, thanks to Christopher Youngs for his encouragement and advice in the planning stages. I also want to thank Vladimir Bodrov, our Russian driver, bodyguard, and friend. I would like to acknowledge the assistance of the curators, gallery owners, critics, and friends who gave us the benefit of their experiences in the field. I especially want to thank my grandmother, Eleanor Blake Kirkpatrick, for instilling in me a love for art when I was quite young and for her support and belief in this project since its inception.

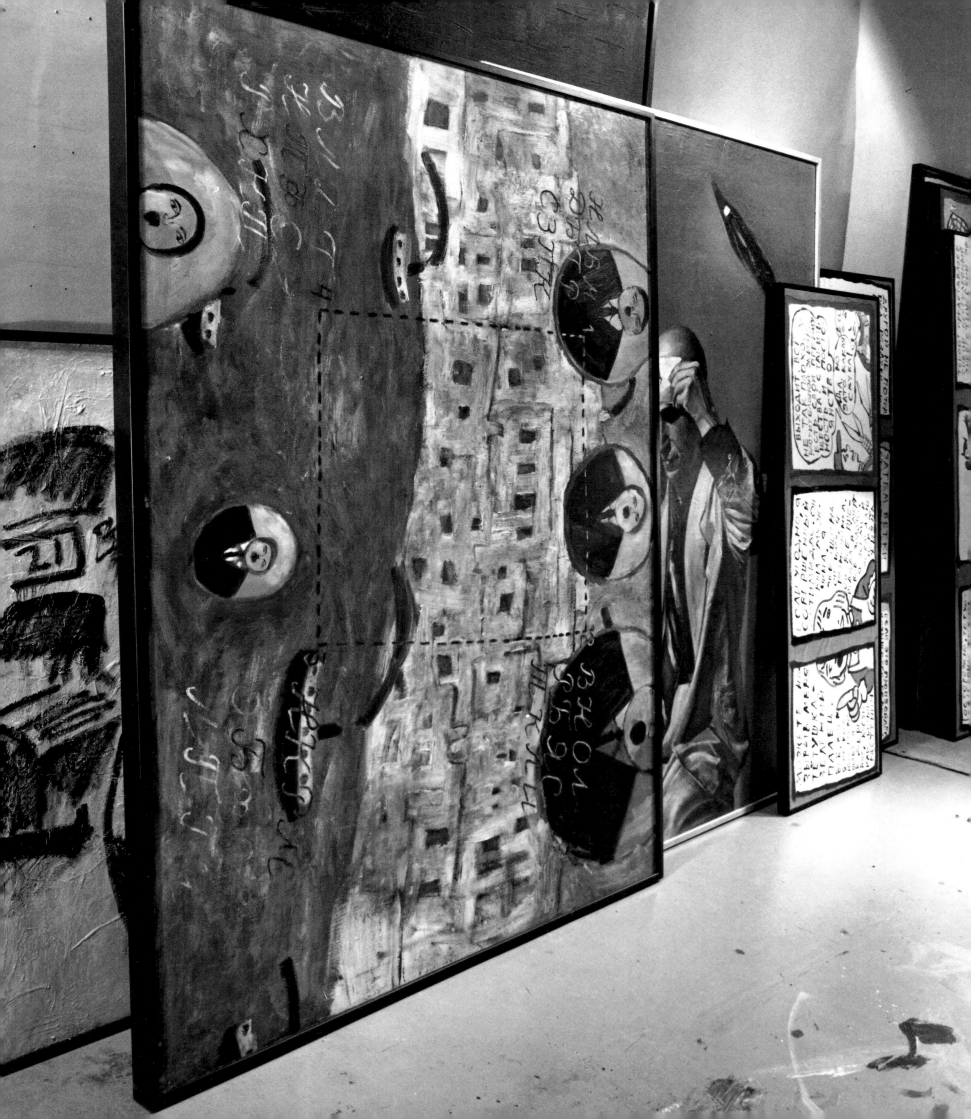

Preface Jon Burris, Curator

"We feel as if this were the most important place in the world for us to be. Such abundance, so much to see: people, theaters, films, churches, pictures, music . . . It is impossible to describe the feeling of exhilaration: perhaps it is in the air . . . perhaps the cordiality of our new friends, perhaps the extraordinary spirit of forward-looking, the gay hopefulness of the Russians, their awareness that Russia has at least a century of greatness before her, that she will wax, while Florence and England wane."

Alfred H. Barr, Jr., First Director of the Museum of Modern Art, New York
"Russian Diary 1927–28." Entry for December 26, 1927

As a curator, I am often reminded of a popular adage in art that says one cannot not know history. Following that, it seems important if we are to fully appreciate the work of the contemporary Russian artists whose paintings are represented in the Keesee Collection, we must first understand something of their own difficult history and that of their predecessors who opposed a rigid system for decades. The work of the Russian avant-garde has held the fascination of collectors world-wide from its earliest developmental years dating back to the turn of the century. For Alfred H. Barr Jr., the first Director of the Museum of Modern Art in New York, Russia in the late 20s proved a glorious place to witness the origination of bold, often radical concepts in art. The work of Vassilii Kandinskii, Kasimir Malevich and Vladimir Tatlin signaled an entirely new direction and certainly one that had never before been explored in Russia where artists were discouraged from experimentation outside of sanctioned academic style. The ideas expressed by this group touched all levels of society. Over their short-lived history, these artists made contributions that are still being recognized well into the 20th century.

Unfortunately, the era of the first Russian avant-garde lasted barely thirty years, hardly enough time to fully develop or resolve issues brought forth by its creators. Joseph Stalin, following the doctrines of the Communist Party which exercised its power over all Russian life, in the late 20s, implemented repressive State control of the arts. He recognized Socialist Realism as the only "art of the people," effectively ending the experiments of the avant-garde. During his purges of the mid to late 30s, those artists who did not conform to the authorized style, or willfully chose to produce art that did not serve the good of the Party, were considered dissidents and faced execution or imprisonment. Those who could not manage to emigrate or did not join State directed artists' unions were forced to become members of an unrecognized and illegal underground. They could not discuss their art with others for fear of being identified and eventually arrested. Of course, the exhibition of their work was absolutely out of the question. This unbelievably oppressive atmosphere would extend beyond Stalin's death in 1953 and well into the Khruschev era of the mid to late 50s. At this time, the government would begin to redefine how art should serve the State. The artists themselves would attempt to define their role in society, but for the most part, held little hope for creative freedom in their future.

By the late 50s, the government began to allow Impressionist works held in State collections to be exhibited and the art of the first Russian avant-garde began to appear in museums. Abstract painting, however, was still labeled a product of the decadent West with no real purpose and went unrecognized. Artists who studied in Russian academies came under strict rule not to pursue such formalist ideologies of modernism. Therefore, any real experimentation with style and content was carried on underground. The value of art was still defined by how easily it was understood by the masses, and how it related to the doctrines of Communism, not by how one might relate to it emotionally or intellectually.

For anyone who wished to pursue a career as an artist in the Soviet Union of the late 50s and early 60s, there was little choice. In order to obtain state support under the Communist system an artist had to become a member of an authorized union. Once a part of the union, they were considered "official." The function of these organizations, such as the USSR Union of Artists, was to award commissions, provide venues for the exhibition of the work of their members and make purchases for Union collections. Most artists who became members were graduates of the academies and strictly followed the Party line of Socialist Realism. Those who expressed a desire for change within this system would come to be known as left-leaning and would later abandon it

8

Protest, Lenin Museum, Moscow, 1992

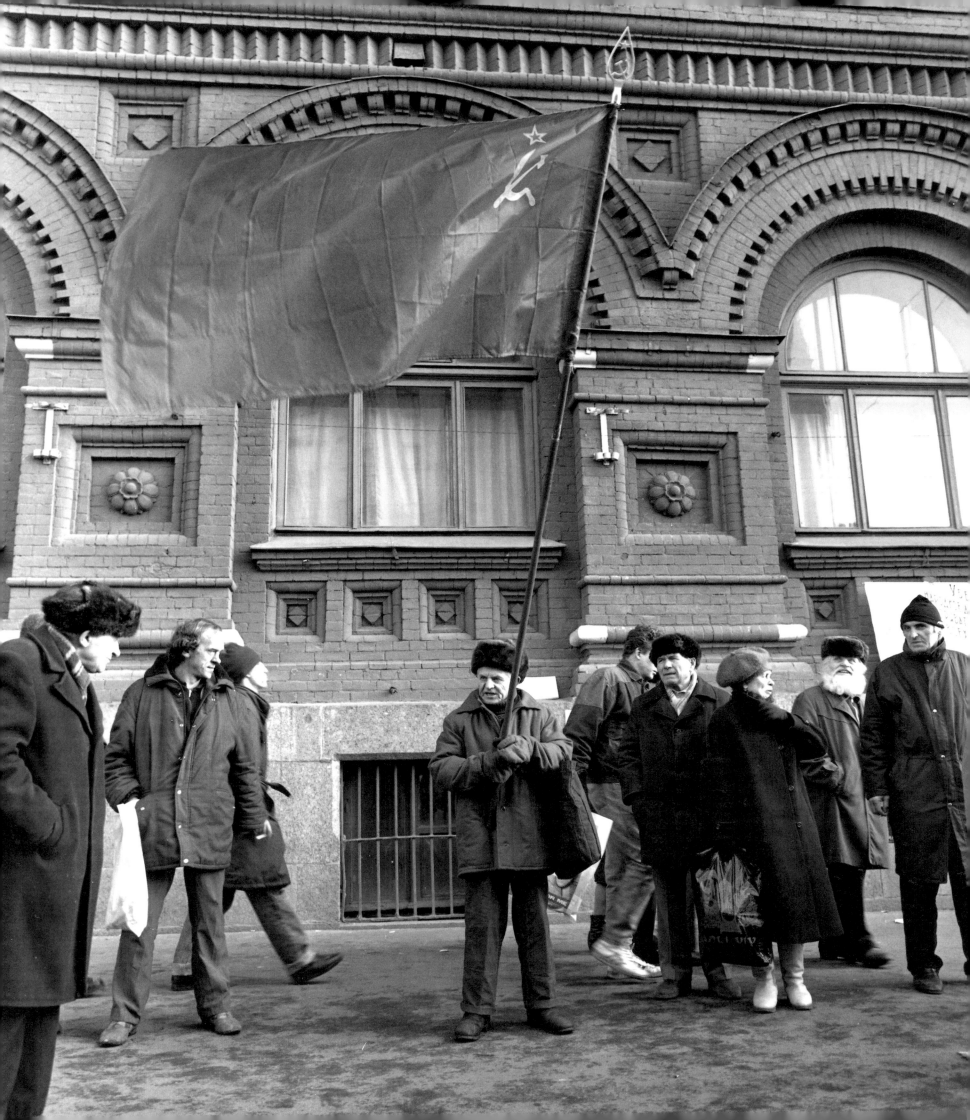

to work independently. Ultimately, it was these artists who would represent the beginnings of the "unofficial" art movement.

Independent artists managed to survive in a number of ways. They often took menial jobs during the day which had nothing to do with their training and continued to produce their art clandestinely. If they were found out, they could be shipped off to work camps or worse, placed in mental institutions, because undoubtedly such activity was an indication of an unstable citizen. Such individuals demonstrated the courage necessary to begin to free themselves of years of intimidation at the hands of their government.

Because their work was dramatically different from that of official artists, the work of the unofficial artists drew the attention of important collectors of avant-garde art. Such collections within Russia were assembled in secret and at times, smuggled into Europe. One of the earliest and most formidable collectors was the Russian-born son of a Greek merchant, George Costakis, who had managed to establish himself by working for foreign embassies in Moscow in the 40s and 50s. It is said that he brought together an impressive collection of paintings by such recognized masters as Chagall, Malevich and El Lissitzky, by simply bartering for diplomatic services and supplies. He was one of the first to support the activities of the unofficial artists. He purchased their work for over twenty-five years, exposing it to visiting foreigners and eventually negotiating to take it, and himself, out of the country in 1978. Later he went on to organize exhibitions of this art in key European cities.

Other Western businessmen and diplomats traveling to Russia in the 60s and 70s began utilizing contacts of various kinds to acquire on-going work by avant-garde artists, assimilating it into collections of modern art world-wide. Two of those who established the largest bodies of work were Paul Ludwig from Germany and Norton Dodge from the U.S. Both have subsequently made their collections available and have created important facilities for the study of this art.

During the decade of the 70s, unofficial artists continued to lead lives which remained closed to outside influence. Communication was difficult if not dangerous. Such isolation forced them into small circles where they created work that was introspective and which they shared only with one another. Meanwhile the government sent mixed messages by loosening and again tightening its control. While it allowed an increasing number of exhibitions of the work of important Western artists, official venues were not made available to Russian contemporary artists who felt a growing need to communicate not only with each other and with an audience. Continuing to organize themselves outside of official channels, the underground artists challenged the government's authority through such activities as staged outdoor exhibitions—the most famous of which came to be known as the "bulldozer incident." In late September of 1974, thirteen artists, in protest of the government's refusal to grant them a public exhibition space, set up their work outside on the street of a small Moscow suburb. Officials brought in water trucks and bulldozers to crush the effort. Art that was not destroyed was taken away. The international press carried the story and the furor that ensued forced the government to allow a fully sanctioned second outdoor exhibition. While this represented a minor victory for the artists, the government's position on what it considered acceptable and unacceptable was unchanged.

By the end of the decade, there was a growing number of young artists whose role models were members of the first generation of nonconformists. They held meetings and exhibitions in their apartments and they formed secret groups with common goals and identities. Their radical experimentation with a broad range of styles and subject matter began to bring them attention from both the public and the press. Some were reprimanded or harassed by the KGB. All were so convinced that change was in the air that they were no longer afraid of what might happen to them.

While the State attempted to maintain its control over the activities of unofficial groups, it most likely realized its grip was slipping when Mikhail Gorbachev assumed leadership of the Soviet Union in the mid 80s, introducing the policies of glasnost (the new openness). Over the next ten years, other events would would serve to strengthen the stance of the vanguard artists. Exhibitions of important international art pre-

sented by American institutions, in cooperation with the USSR Ministry of Culture, would enter Russia. Such exhibitions would enable Russian artists to study trends and movements that had been inaccessible to them. The conservative artists' unions would agree to exhibit non-union artists in their exhibition halls. American as well as European auction houses would organize sales for the unofficial artists, bringing in collectors and dealers from the West eager to "discover" new talent and willing to pay record prices for their art. Undeniably, the unofficial artists represented a new vital force.

The contemporary Russian art scene at the dawn of the 90s became increasingly segmented, like so many pieces of a puzzle. As there was no longer a dependency on the artists' unions for acceptance and approval, or for their livelihood, issues between official and unofficial factions became unimportant. At this time, they began to exhibit with one another regularly in venues formerly reserved for official art. A number of artists still worked in informal groups, but it was more for the purpose of sharing communal studios than for collective influence or support. There existed a new and unaccustomed atmosphere of competitiveness as an international market for their art developed. Andrew Solomon points out in the introduction to this catalog that this competitiveness had both positive and negative effects on the community as a whole. Certain artists were promoted far beyond their value for commercial reasons and others, were curiously ignored. As a result, they shared certain needs. Among them was the growing necessity to identify themselves in context to an "outside" world. The need to not only comprehend, but adapt to the vagaries of a free market economy, and immediately, the need to interpret their new freedom. Although it seemed to be a confusing time for them, the early 90s represented an important transitional period in the ongoing history of these artists.

Unquestionably, for collectors, or anyone interested in studying Russian culture on a broad scale, the country had once again become an intriguing place in which to witness history in the making. It was in 1988 that Christian Keesee, an American businessman and collector, first became influenced by a group of young painters whose works he saw while on a business trip to

Moscow. Keesee, who had been primarily interested in contemporary American art from the decades of the 60s and 70s, found himself surprised by what he described as "the fresh ideas reflected in their art," and was curious about the undeniable homogenization of Western styles that had somehow filtered through. He wanted to know what influenced the artists to remain in their country during these most difficult of times and what they thought about the social changes taking place around them. What issues were important to them? These questions were unanswered over the course of his first trip to Russia as he never actually met any of the artists, but his interest in their work was strong enough to prompt him to pursue it after returning to the United States.

Keesee began to research contemporary Russian art through whatever sources he could find. Unfortunately, the few catalogs that had been published were produced by American galleries who had struck deals with the first of the emigrant artists. Their work left the distinct impression of catering to a Western idea of what "Russian" art should look like. It was impossible to look at this art and say it possessed the vitality of the work he saw in Moscow. Between 1989 and 1991 Keesee initiated discussions with other collectors and curators. He continued to read about the artists' activities in art journals, but realized the only way he would truly be able to involve himself with it was to return to Russia.

In June of 1992, Christian Keesee and I began the first of three extensive trips to Russia aimed at learning about contemporary Russian art and acquiring paintings for a collection which would eventually travel, realizing another of Keesee's goals, to share his fascination of this art with others. We focused our efforts on Moscow and Saint Petersberg for a reason. Although there is a common debate over exactly what constitutes "Russian" art (Russia being only a part of the newly recognized Commonwealth of Independent States) it is generally accepted that for purposes of communication and interaction, artists usually end up in these two cities.

Over the course of our meetings with more than 100 artists, we occasionally heard stories of how they had come from small towns in Georgia or from large cities in the Ukraine with an obvious

need to discover new outlets for their art, primarily through a developing system of commercial galleries located mostly in Moscow. By comparison, we found St. Petersburg to have a more relaxed air. As a result, even though a number of important artists choose to live there, they spend time shuttling back and forth. Therefore, most of our attention was directed toward Moscow.

While practically no monographs on the work of the contemporary Russian artists exist, there have been a few notable survey exhibitions organized by American institutions whose accompanying catalogs we studied prior to our trips. In 1989, the Modern Art Museum of Fort Worth organized an exhibition of ten American and ten Russian painters entitled appropriately, *10+10*. It was circulated in both countries. In 1990, the Columbus Museum of Art presented *The Quest for Self-Expression: Painting in Moscow and Leningrad 1965–1990*, an ambitious exhibition that brought together work from the avant-garde over an important twenty-five year period. The catalog for *The Quest for Self-Expression* provided a detailed history of these artists and remains one of the best resources available on this period.

Another valuable resource was Andrew Solomon's book, *The Irony Tower: Soviet Artists in a Time of Glasnost*. Published in 1991, it chronicles the author's time spent within the circles of the vanguard artists following the infamous Sotheby's Moscow auction of 1988. Living and traveling with the artists as they prepared for exhibitions of their work outside of Russia, Solomon was able to interpret how the early days of glasnost and the growing international interest in their art affected them on a personal and professional level. His stories often read like a travelogue of our own experiences, so we arranged to meet with him to discuss our project in its early stages. We are most fortunate to have his contribution to this catalog in the form of an introduction to these artists. It provides an overview of their recent history and his insight into their lives broadens our understanding of their art.

We carried with us a list of artists whose work appealed to us as we arrived in Moscow in June of 1992. We hoped to meet the artists we had identified and have them introduce us to others.

Somewhere along the way, we had been given the name of the head of the Moscow Critics' Union with the suggestion that his organization could assist us in locating them. Our first meeting with this group was disastrous. They found it hard to understand why we were interested only in paintings and why our list was chiefly comprised of unofficial artists. In our discussions, they proposed a very narrow agenda, influenced no doubt, by years of operating on official levels. We were told that practically none of the artists we wanted to meet were in the country, but that they would assign an assistant who would guide us to the studios of "more important" people. Fortunately, we had been provided a sympathetic interpreter who eased us out of the situation.

We had also come with the names of two Moscow collectors, Tania and Natasha Kolodzei. We arranged a meeting with them shortly into our first trip and were able to view their enormous collection which occupied every available space in three small rooms of a fourth floor apartment just off Leninsky Prospect. They also had an impressive library which provided us with information on artists with whom we were unfamiliar. For many years, Tania had been an ally to the nonconformists though she had worked at times for official branches of government arts organizations. She had followed their work, helped them organize exhibitions and developed lasting friendships; the kind born of a common struggle. For over two decades and at extreme personal risk, she advised collectors from the West who, like us, had found their way to her door. Her daughter Natasha grew up studying the art of the underground and shared her mother's passion for collecting. They were a formidable team and our association with the them allowed us to meet a broad range of artists from Eduard Shteinberg, an important member of the first generation of unofficial artists, to Farid Bogdalov, one of the new generation of conceptualists.

Getting around Moscow, a sprawling city with a population edging steadily past ten million, proved less of a problem than we expected. This was due in large part to the ability of our full-time driver Vladimir Bodrov. Recommended by our hotel, he was a part-time economics student who had previously been an intelligence officer in the Red Army. A resourceful and consciences young man, he also became highly protective of

us which is a value not to underestimate in Moscow where the crime rate is alarming and the activities of the Russian mafia are pervasive. We were also fortunate to find a part-time translator, Alexi Sinodov who had studied at Cambridge and spoke English with a clipped British accent. He had many friends who were artists which made it easier for him to interpret our questions. Later, we came to depend on a network of gallery owners, shippers and importers to assist us in getting the paintings we purchased out of the country which was one of the most arduous tasks of assembling the collection.

Even Muscovites who have spent their entire lives negotiating the system will agree that the smallest of tasks can take an inordinate amount of time. There are no telephone books in all of Russia, so in order to locate someone, you must already have their number, or at least the number of a friend of a friend. Setting up appointments involved a chain of events whereby one of our representatives would get word to one of the artists that an American collector would like to visit their studio. They would in turn tell another, and another, and another, and so on. The fact that several artists lived in communal studios, taking the names of their locations like Trochprudnii Lane or Chistoprudnii Boulevard, made it far easier to track them down. We were often surprised at just how many occupied these dilapidated apartments, centered in Moscow, that had long been abandoned as livable. In the winter, they were cold and in the summer, dank and musty smelling. But even with their crumbling walls, sagging floors, and exposed wiring they had an endearing quality and we would come to spend most of our days in such places.

Depending on their respective success, some artists had larger apartments that doubled as studios where they could actually spread their work out for viewing. Both Natalia Nesterova and Andrei Medvedev's apartments were spacious and full of light. They could accommodate large canvases and work on several pieces at one time. This is a luxury for many painters who produce in a series. But, for the majority, there are few luxuries and the norm is a small, cramped space which contains the materials of both private and professional life. The process of meeting with the artists generally began with a round of introductions and an explanation of our project, followed

by a brief interview. We often made Polaroid photographs of paintings for viewing and discussion later. This was especially helpful when studying pieces in a series. If we decided we liked a work well enough to purchase it, we would return to the studios and begin negotiations. These were usually followed by celebrations over the signing of contracts and the exchange of hard currency. There was always vodka.

From the outset of the project, we agreed on the importance of supplementing the acquisition of the art with interviews with the artists. In addition to information on specific works we purchased, we tried to get some feeling for how they viewed the world from which they had been cut off. Did they see Western journals? Did they know the work of other international artists? Did it have any impact on them? Eventually, we gained valuable information about their backgrounds, their workings with one another and an interpretation of their art in their own words. It became our goal to put a face to the artists and a description to the pieces we were acquiring. In all, we produced ten hours of video-taped interviews and over 30 hours of audio-taped conversations. With the exception of only two artists out of thirty-three whose work we acquired in a two year period, all patiently cooperated as I photographed them in their studios. At times, we purchased from galleries and attempted to catch up with the artists later. Unfortunately, we didn't get to meet Nikita Alexeev as we were never in the same city at the same time, but we were able to correspond with him and acquire a portrait. The young artist Oleg Golocii, whose work we were introduced to by gallery owner Marat Guelman, died tragically between two of our visits and we never met him. Photographs became hard to locate and the decision was made not to include an image of him in this catalog.

There exists in Moscow a developing system of galleries that function not only as a means of support , but as centers for a range of artistic activities. Spread throughout the city, and in a wide variety of unusual spaces, the majority try hard to imitate the concept of galleries in the West, staging regular exhibitions and openings, publishing catalogs and educating the public about their artists. A few of the more interesting ones like the Guelman Gallery, Gallery 1.0 and Skhola (Russian for school) are part of a complex

located in a quiet, historical neighborhood just off the Moscow River, overlooking the Kremlin. Collectively, they operate on behalf of the Center for Contemporary Art, organized in 1991 by Moscow critic Leonid Bazhanov. The Guelman Gallery specializes in artists from outside of Moscow, in particular, a group of Ukrainian Neo-Expressionist painters. Marat Guelman was formerly an electronics engineer with no real training in art, just an avid interest. He managed to influence a number of other new dealers to approach the "business" of art ethically and as a concerted group. He was also one of the organizers of the first Moscow International Art Fair in 1991. MIF, as it is called, now takes place on a yearly basis, drawing the same kinds of crowds as art fairs throughout Europe.

There is also the Aidan Gallery, named for its owner Aidan Salakova who represents an impressive stable of recognized artists and up-and-coming talent working in a variety of media. Over the last several years, interest in photography has increased and all of the galleries now include it in their regular schedules. A small number of artists are also experimenting with computer manipulated imaging, but as access to equipment is limited and expensive, this doesn't represent an area that is expanding as rapidly as it seems to be in other countries.

All of the gallery owners were extremely helpful, showing us a wide range of material and providing us with catalogs and biographical information on their artists. They were willing to set up appointments and make introductions and ultimately they assisted in the process of importing works.

The majority of the artists and all of the galleries we ended up dealing with, were to be found in Moscow. Yet we made frequent trips to St. Petersburg as there is a well-developed community of painters there. By comparison, the pace is quite different, a little slower and not as pressured. While space is not so much a problem in St. Petersburg, the lack of commercial galleries is, so they continue the practice of "Aptart" (short for apartment), exhibitions. We visited several private apartments, but only one communal studio located at Pushkin Square 10 where as many as fifty artists live, work, and exhibit. We were told by one painter who has lived in both cities, Ivan Olasuk, that it is much harder

for an artist to make a living in St. Petersberg. "I prefer it here. I seem to be able to take more time to study and work. But what difference does it make if there's no place to sell your paintings? You end up in Moscow or try to meet dealers from Europe. If we're behind the rest of the world, it's because it's taken us so long to learn to communicate."

Wherever they may live, and however they may function, the new generation of Russian artists still face the problem of arriving at an identity, free of the stigmas of the past. This alone may become one of the most debatable aspects of their work in these early transitional years. Sergei Bugaev, who adopted the professional name of Afrika, arrived in St. Petersburg in 1980 at the age of fifteen and soon became a member of an influential circle or artists and critics. While he lives most of the year there, he maintains an apartment in Moscow and travels extensively, attending openings of his exhibitions in Europe and the United States. Afrika believes his gener-

ation should be more aware of the importance of communication for the purpose of integrating themselves into a global community, "Malevich studied the work of European artists like Picasso and Matisse, and then used aspects of it to create Suprematism. Not long ago, I saw the work of Donald Judd in New York and realized that he had probably studied Tatlin's machine sculptures. I think for art to serve a purpose, it must have universal influence."

Others, like Moscow Conceptualist Gia Abramishvilii , fear that, "this openness in our society may adversely effect our art. Not too long ago, we existed like a submarine crew, living on our wills and very little fuel. Today, there is a feeling that one must go 'outside' to prove how valid one's art is. As far as I'm concerned, freedom comes from within and I still prefer for the world to come to us."

Given its transitional nature, it is obviously too early to arrive at clear definitions for what we

refer to in this exhibition as the "New Russian Art." After all, we are only shortly into the post-Communist era from which it comes and this is still a time of great experimentation. American critic Donald Kuspit in his analytical essay for this catalog writes, "The Russian painting in the Keesee Collection often reflects Russian interests and iconography, social reality and temperament, it also makes an important contribution to international art." And to once again quote Andrew Solomon, "The history of the avant-garde has been a history of making something great and astonishing of circumstances of difficulty and uncertainty." Bearing whatever their future may hold, the artists whose works are assembled here will undoubtedly continue to make contributions to the history of 20th century art that will be as lasting as those made by previous generations of Russian artists. By sharing this collection, it is hoped that Western audiences will better understand the importance of this truly significant moment in time.

Introduction Andrew Solomon

In August of 1991, I happened to be in Moscow, visiting some of the nonconformist contemporary artists who comprise what has been called the Russian vanguard. It was a good summer there: the weather was all right; food was not scarce for those with money (the artists all had money at that time); and autumn exhibitions abroad were being planned. In the meantime, everyone was enjoying the peace and quiet. Those who had dachas had opened them up to friends, and on very hot days we would all go swimming in the Moskva River. Sometimes there would be a shashlik party, and we would go to the countryside and eat meat grilled over an open fire. On such evenings we would stay up drinking and talking until very late. We had so much to discuss: there had been some difficult periods for the vanguard in the preceding years, and now, in the new calm, it was time to try to reconsider all that had happened.

These artists' world had blown apart in the early glasnost days with the Sotheby's Sale of Contemporary Russian Art on July 8, 1988. I had attended that sale, and had first met many of these artists during it. I had watched their faces as they saw paintings that they had previously been forbidden to exhibit and unable to sell go to prosperous Westerners for hundreds of thousands of dollars. In the years that followed I had seen them move from claustrophobic obscurity to international celebrity—and had seen their historic sense of identity destroyed. I had seen the high ideals that had always characterized

the Russian vanguard challenged by material wealth, fame, and the decay of the government they had for so long opposed. If you have been in the habit of defining your probity in negative terms, then it is very difficult to figure out what to do when the old enemies fall; emancipation was in many ways an uncomfortable business for those who had built not only their view of the world but also their art around their experience of oppression.

But by August of 1991, the artists of the Soviet vanguard had arrived at a fragile new sense of identity. Life was not so serious, not so difficult. For these people, glasnost had worked out pretty well. They were enjoying their freedoms and were no longer intimidated by them; they had figured out how to combine success and integrity. Of course there was a lot of petty bickering and competitiveness, but there was also a feeling of warmth among the artists that had not always been in evidence during the previous transitional years—the era that had begun with Gorbachev's social liberalizations in 1987. I felt very relaxed in Moscow; that oppressive city—which, for all that I loved it, had always had a threatening air to it—now seemed to be less overwhelming. Many Western luxuries that had been previously unimaginable were now readily available. Despite the rise in street crime, the city felt safe and free, and everyone believed that reform had progressed so far that the oppressions of the Communist era could not return. The artists were sometimes cynical in

the casual fashion of iconoclasts, but they were at last truly unafraid.

On the morning of August 19, I went to the communal studios on Chistaprudnii Boulevard which many of the artists shared and where some of them also slept. A friend had called that morning to tell me that Gorbachev had resigned and that something strange was afoot. But I had no sense of what was really happening; Russian politicians are given to much melodrama, and forever using maudlin rhetoric to stir up the population. Gorbachev had resigned; tomorrow Gorbachev would probably un-resign—this was at first the attitude of many Muscovites. I went to the studios to see whether anyone had more information, and found all the artists huddled around a television set and a radio. The television showed only reruns of Tchaikovsky ballet; there was no news, and none of the ordinary programs were on the air. The radio was receiving BBC world service through a thick haze of static. "They haven't done this, ballet on every channel, since Brezhnev's death," one of the artists told me. "It's the tradition when something has happened about which there is nothing to be said." Of course, it was the beginning of the coup. "I think we have to go fight against this," the artists told me. "It's not a choice." And so I joined them as we participated in the resistance. Many of the people who gathered around the Russian Parliament building (the White House) for the length of the coup were members of the local intelligentsia. These men and women had been

Two Soldiers, Moscow, 1993

among the prime beneficiaries of glasnost, and they took immediate responsibility for the difficult matter of sustaining those freedoms on which they had become so reliant.

It had been the birthday of the artist Konstantin (Kostya) Zvezdochetov a few weeks earlier, and the painter Andrei Filippov had made him "the biggest Russian flag in the world," since both Andrei and Kostya had been doing work that reflected the tension between the Russian spirit and the Soviet system. This extravagant length of fabric had been sitting in the corner of the studio for days. Now Kostya sat wrapped in it, and he and Andrei made jokes about Russian history and Napoleon. The mood was one of high hilarity; as in those Khrushchev and Brezhnev days of which I had heard so much, irony was the only way to deal with fear and crisis, and so the pace of conversation was unbelievably quick, the witticisms as sharp and brittle as the news. An unknowing visitor to this circle might have failed to catch the tension and anger behind that first day's banter, but of course the artists were building up the courage they feared they might need in the period to come. For all its echoes of the past, the situation was very different from what it had been when Brezhnev died. This revolution would ultimately require that the artists drop their ironies, their obscure personal language, and act authentically and directly. This time, there would be neither time nor space for metaphor, and there would be an urgent need for what the artists' metaphors had previously served to convey.

The first afternoon, everyone helped with the building of the barricades. In between these exertions, the artists stopped to talk to soldiers who were sitting in tanks all over the city. "So," someone would ask, "you've been in the army for a long time? Where do you come from? Ah, my grandmother came from there. Have you been to Moscow before?" At the end of fifteen minutes of such chat, the conversation would suddenly turn. "Listen, you don't know what your orders will be tonight, and I certainly don't know, but I want to tell you that I and my friends will be defending this building. We'll be sitting outside it. Don't shoot us. If you have problems, if you need to go into hiding from your generals, we will hide you." It was the gift of these artists to humanize politics around them, to change

great abstracts into concrete realities. That weapon was in some instances stronger than the military machine with which they were faced.

That night after dinner we met again at the studios on Chistaprudnii Boulevard. Andrei Filippov took the enormous flag he had made for Kostya, and told us that should we become separated, we might meet beneath it. Some artists walked down to the Parliament. I went down in Sergei Mironenko's car; others followed just behind, so that we were like a miniature motorcade. A crowd was gathered at the back of the Parliament building, listening to the endless speeches, but the artists chose to stand on the other side, since these speeches were boring. The crowd included most of Moscow's vanguard artists, who, with their glasnost-era money, connections, international passports, and visas, could easily have left behind the atrocities the coup leaders' cruel regime promised to impose, so long as they departed before the borders closed (and every fifteen minutes we heard another rumor that the borders were closing). It never occurred to them to leave. It was almost like a great cocktail party outside the Parliament building, with people who hadn't gathered together in ages stopping under the giant flag to debate those eternal subjects that have always been so attractive to Russians: truth, beauty, freedom, suffering, and critical theory. When at about 1:30 a.m. someone came out to say that we might soon be attacked by tear gas, and gave directions on the correct procedure in the event of such an attack, I suggested that we go in search of wet rags we might hold over our faces. "Please," said Georgii Litichevskii, "we'll go in a moment. I just want to hear this point about deconstructionism."

By 2:00 a.m., we were getting cold and tired and bored, and we agreed that some of us should go home so that we could return, refreshed, the following day. "We can't all just live here for the next six months," one artist sensibly pointed out. As we walked toward the barricade where we had parked earlier, we were accosted by a striking woman with blonde hair and a pale gray coat. She explained that she was helping to inflate a helium balloon to fly over the Parliament, and she wanted to attach to its cord banners of resistance. "You have the biggest Russian flag I have ever seen," she said. "Ours is

so small that when it is high over the building you will hardly be able to identify it from the ground. But if you will give me *your* flag, then the people of Russia will be able to see it, and take hope from it."

Andrei Filippov smiled. "Of course you can have it," he said, handing the flag over. What had been wholly ironic between Andrei and Kostya (when the flag was given as a birthday present), then semi-ironic as the banner of the vanguard, had become at this moment of crisis wholly un-ironic; it had settled into a new authenticity, the authenticity that had always lingered behind the ironies. It is this curious blend of irony and sincerity that, more than anything else, defines the work of the Russian vanguard artists, including those who are in the Keesee collection. Westerners frequently ask what the new Russian art looks like, and there is no answer to that question: each artist has a visual language that is his or her own, and no single set of visual criteria holds this work together. What the artists of the Russian vanguard do have in common is a powerful ironic stance on matters that are, to each of them, tremendously important and significant. What they have in common is a capacity to illuminate great truths by skirting them.

On the morning of the third day, everyone was still gathered outside the Parliament, settling in for what was starting to look like a long wait. Some of the artists wanted to see where the three victims of the coup had been killed the previous evening, and so several of us went to that place, near Smolenskaya. Where the bodies had been, we found flowers; sixty or seventy people were standing and talking about the killings.

Then a young man—unshaven, wire-rimmed spectacles, gesticulating with a crumpled cap that he held in his hand—came running from the barricade. He told us that there were tanks coming and begged us to come and stop them. Without discussion or question, we all trudged out to the limit of the many-tiered system of defenses. We were prepared for anything, though there had been too many rumors of tanks by then, and no one had really expected to see one. They arrived almost immediately. The soldier in the front tank explained that they had come to destroy the barricade. He said he wanted no argument, that orders were orders, and

that we would have to get out of the way or be run down. The man who had led us there responded that we held our ground not in aggression, but to defend the rights of the people. "We are only a few, but there are tens of thousands at the Parliament, and across the country," he said. Others joined in, including the artists. They spoke of democracy and commented on the nature of emancipation. "You are very young," they said. "Perhaps you do not remember the Brezhnev days. Let me tell you what they were like. They were terrible." The language was a language that no longer exists in the United States of America, where we take democracy and certain corollary freedoms for granted; it was the Jeffersonian language of people who had discovered these principles for themselves, and could therefore both articulate and value them.

The soldiers looked at one another and then they looked at the mob before them. The artists and others were so wet, so cold, so impotent; it had been raining for days, and we were all catching the flu. No one had any kind of solid defense, and whatever people said they said only out of authentic belief. After a terribly long moment of silence, the soldier in the front tank shrugged as though he were doing nothing more than give way to the inevitable course of destiny, and said, "What you have said is true, and we must bow to this truth that is the will of the people." He instructed us to clear enough space for the tanks to make U-turns. All of us—friends and strangers—embraced one another, then cheered. In the Russian way, this moment of moral victory took on the quality of a miracle.

I have spent a lot of time over the last six years with the artists of the Russian avant-garde, and I cannot say that this level of high drama and meaningful frankness was sustained throughout. I have started with this description of the coup because although it was, of course, extraordinary, it was also in some sense very characteristic. You cannot understand the Russian vanguard without understanding the heroic (but curiously self-deprecating and fantastically egotistical) stance of the artists. The story of the Russian avant-garde is one of an identity forged through difficulty, compromised by success, and ultimately reinstated at a moment of crisis. The work in the Christian Keesee collection is, by and

large, from the period after the coup of 1991. Some of it is by members of the heroic older generation, and some of it is by artists who did not begin to work until later, very young artists who are now the newest wave in the continuing development of the Moscow art world. But all these artists are formed by this tradition of complex sincerities and ironies.

The Russian vanguard movement was born after the Moscow World Festival of Youth in 1957. Everyone had understood in Stalin's day that to create work in which you were trying to communicate anything was too dangerous, too obviously foolish even to consider, and no one did it. Secrets were too hard to keep. "What continued were ideas," one artist has said, "and they continued not so much secretly as deeply." The festival was the first sign in the cultural world that Stalinism was giving way to something less closed; it included exhibitions of many artists from the West whose work had previously been forbidden in the Soviet Union. Many would-be artists created their first work after visiting the festival, but many others were paralyzed by it and went into a mode of frantic pastiche from which they never escaped. The years that followed were chaotic. There was an ebullient sense of liberation everywhere, and people tried experimental poetry, experimental painting, experiments of every kind. Certain Western authors were translated and became immediately popular, though they were often read without either social or literary context. Unofficial art— not political, but not made to fit with the narrow state agenda of Socialist Realism—was suddenly everywhere in a thousand diverse forms.

It was not until the late 1960s that a group of well-educated, quiet men, all of them with official jobs in the establishment, began to make a kind of secret art. None of them were members of the Painting Section of the Union of Artists, where their work would have been drawn into the tight political constraints of the Soviet system and the Union itself. They instead sustained the appearance of being conscientious citizens, fulfilling their professional duties in an exemplary manner, and worked by night on projects of their own. Only their very closest friends knew that they were leading these double lives. By the early seventies, one artist, Ilya Kabakov, had emerged as the leader of this group. Perhaps the

best one can say of Kabakov's work is that each new image on paper, each idea articulated in conversation, each painting, is a hint of some large and synthetic worldview in which the things that can seldom be ordered are made sensible. Kabakov's work is never overtly about politics. It is about withdrawing from Soviet life into the secret truth of your own being. In his world, it is braver, and also perhaps wiser, to fight political reality with the absence of politics than to fight with other politics. Kabakov's work is about retrieving people's humanity from the dehumanizing circumstances of life in the Soviet system, not about a new set of superhuman ideals or a bill of rights.

A circle grew up around Kabakov. Though he always modestly disclaims responsibility for the advent of the Russian unofficial art movement, there is little question that he remains one of the most powerful influences on the work of young artists. During the 1970s Kabakov's home was a gathering place for younger artists, who would meet there regularly to discuss art. Some of these artists were very productive, but since they showed their work only to one another, there was no reason to produce it in vast quantity. Often they would sit in the kitchen at Kabakov's studio to discuss theory, to compare notes on what little information they could obtain about art in the West, to critique new ideas. They began to create a language of art that was very much their own, full of mysticism and ritual, touched by Asian Zen writing, by Hermann Hesse, and by Carlos Castaneda. They were not dissident artists; they thought it was stupid to make obviously political work and get in trouble with the KGB and live out your days in the Gulag. By adopting a more subtle model, they made work that was complex, bewildering, and obscure to the uninitiated observer, but that was full of rich meaning for those who knew how to read it. Kabakov's contemporaries—Erik Bulatov, Oleg Vasilyev, Eduard Shteinberg, and Ivan Chuykov—remained in this circle, and increasingly interesting work began to come also from the younger artists: Andrei Monastyrskii, Kabakov's great disciple; Nikita Alexeev, a high intellectual and a leader in mysteries; Irina (Ira) Nakhova; Georgii Kizevalter; and later Dmitrii Prigov. Other artists included the Mukhomors (the word means "toadstools"; these young artists were an eccentric, daring, sometimes

17

radical group)—Sergei and Vladimir Mironenko, Sven Gundlakh, and Kostya Zvezdochetov; friends of the Mukhomors, including Andrei Filippov, and, later, Nikolai Ovchinnikov; the artists of the circle of Komar and Melamid—Vadim Zakharov, Viktor Skersis, and Yurii Albert; and the Odessa artists—Sergei Anufriev, Larisa Rezun-Zvezdochetova, Yurii Leyderman, the Peppers (Oleg Petrenko and Lyudmila Skripkina), and Leonid Voytsekhov.

These waves of younger artists began to challenge the secrecy that had been such a crucial part of Kabakov's original model; they wanted to take their art out of the private context of their own apartments. In 1982, Nikita Alexeev announced that his apartment was a gallery, and he invited other artists to hang their work in it, then opened it to the public. This marked the beginning of the Aptart (for "apartment art") movement. Aptart frightened some of the older artists; if the infrastructure of the vanguard had depended on circles of relative initiation, then Aptart was about the deconstruction of those circles. It flew in the face of convention and discretion, and it was an enormous success; Nikita once boasted he had a thousand visitors in a single day. Though there were occasional police raids on Nikita's place—"the Aptart pogroms," as the artists like to call them—it was difficult for the police to do much, because though the work was now being shown publicly, its meanings were still complex and encoded. To the authorities, its real meanings were incomprehensible, which was perhaps even more threatening to them than comprehensible meaning would have been.

In the end it all got to be too much for the powers of state, and in 1984 they decided to act. By this time the artists of the vanguard had achieved enough acclaim in the West so that it would have been embarrassing and difficult to put people in prison. But it was possible to call for military service those who had earlier avoided their military duties, and the authorities shipped the Mukhomors off in various punishing directions. This sent shock waves throughout the existing avant-garde, and many artists, terrified, withdrew again into a kind of depressed secret existence. Meanwhile, however, three new artists—Andrei Roiter, German Vinogradov, and Nikolai Filatov—took jobs as watchmen at

an abandoned kindergarten and proceeded to turn it into an art center. Nikita Alexeev exhibited there; so did other new artists, including Georgii (Zhora) Litichevskii, Gosha Ostretsov, and Sergei Volkov. Bit by bit, glasnost was dawning. When the Mukhomors came back from their dangerous military service, they found a changed world. What had once been dangerous now was tolerated; within a few more years, this toleration had turned into encouragement. At this stage, still more groups had come into existence, including the Champions of the World. Founded by Kostya Zvezdochetov, Gia Abramishvilii, Boris Matrosov, and Kostya Latishev, the Champions tried to set up rules within which to make work, and so they played on the questions of authority and creative control which had been such a key element in ordinary life under the Soviet system. Later, the group would transform itself into a loose federation of young painters, all working with questions of narrative. Andrei Yakhnin was one of those who joined the group at this time.

Moscow is its own world, but so is St. Petersburg, and they are very different from each other. Whereas the Moscow artists are intellectuals, the Petersburg crew are intensely visual, and their work often relies more on appearance than on ideas. The elegant, spare compositions of Timur Novikov eventually set the standards for the group now known as the New Artists. In Petersburg, the artists are in general incredibly cool. While the Moscow artists sit up in grimy kitchens, drinking and discussing philosophy, the Petersburg artists go dancing, smoke hash, and discuss fashion. Petersburg is a more beautiful city than Moscow, and the beauty of it creeps into the minds of the local artists; it is a decaying, decadent beauty, sensual and old and seductive, and the artists like to see themselves as "the mad and hemophiliac children of a hundred years of incest," as Afrika (Sergei Bugaev), the city's cultural mascot, has said. They are creatures of consummate style, pop artists par excellence. Afrika is the smoothest one of them all, with a vast intelligence tuned as much toward the synthesis of disparate existing ideas as toward the generation of new ones. He is eternally playing games with the cool self-assurance of someone who knows how to play every layer of meaning against every other layer. The other artists of this circle, Georgii Guianov, Irena

Kuksinaite, Andrei Khlobystin, and the necroealists (Yevgenii Yufit, Andreii Mertvii, Vladimir Kustov, and Sergei Serp) all worked in a related mode. In the days when the Moscow artists had to do their work secretly and in hiding, the artists of Petersburg worked openly. The city was not monitored as closely, the artists were not so much interested in ideology, and everything was always brighter there.

The hints of openness that had appeared in the early glasnost period were confirmed with the Sotheby's sale in 1988. The sale was organized in association with the Ministry of Culture, and it represented a hodgepodge of ministerial, commercial, and Western priorities. It included some very fine work by the best artists of the Moscow avant-garde, but it also featured works by old union hacks and work by obscure artists who chance had suggested or "discovered": the collection of work had no real coherence at all. Sotheby's hyped the sale to death in the West: those who came were escorted around Russia with a degree of pomp and circumstance such as Brezhnev himself had hardly dared to imagine. They would meet the authentic Russian artists in their authentic Russian studios—a kind of intimacy that, in Soviet Russia, seemed very wondrous and exciting. There would be caviar everywhere, and galas and champagne. The people who showed up for the Sotheby's sale were as unlikely a jumble as the pictures in it. Though some of them were dealers or serious collectors, many had come along for the glamour of the whole undertaking, with a vague sense that they were participating in a historical event: there were lesser members of the European nobility, a retired baseball player, a few academics, someone who was making a purchase on behalf of a famous rock star, and sundry others.

Until this time the artists of the Russian avant-garde had essentially worked without any real market at all. The meanings of their work were referential, interior, and secret. The key to understanding their art was a personal knowledge of the artists themselves and of the context in which they had been operating. For this work to be seen suddenly by people who were not only outside to the circle of the artists, but also unacquainted with the realities of Soviet daily life, was strange indeed. Naturally, there were few people at the Sotheby's sale who understood

what the art was all about. Given that many of them were buying pieces almost as souvenirs, with little understanding of or interest in the works' buried meanings, their purchases tended to be based more on appearance than on content. The pictures that would look good in a living room realized the highest prices.

This threw the artists into a state of vast confusion. Artists who were, by generally accepted internal standards, very second-rate sold for vast sums of money, while artists whose work was generally seen to be profound and far-reaching were sold for much less. To the artists it appeared that all their understanding of art must run contrary to Western values; trying to distinguish between the jet-set buyers and the long-suffering artists was intensely frustrating. It was necessary for the artists to recognize that what had most readily sold was not necessarily what an informed Western audience would deem the best art. At the same time, the fact of the matter was that even the artists whose work had sold badly had taken in profits of which no one would previously have dreamed. There were no painters in Moscow in June of 1988 who would not have been pleased to sell a picture for $1,000, and most of them would have felt fortunate to have sold something for $100. The work of an artist called Grisha Bruskin was at the top of the Sotheby's sale: one of his pictures realized $416,000. Other artists in general reached at least the $10,000 mark. All at once, these radicals, who had operated outside of their society in conditions of great material deprivation, became members of a new financial aristocracy. Although in the end most of Sotheby's money was kept by the Ministry of Culture, a new level for the sale of Russian art had been established.

As their pictures sold to Westerners, the artists, of whom the government had until that moment been rather mistrustful, emerged as potential sources of hard currency in an economy desperate for cash. The whole society was loosening, and the artists were able to take advantage of this. At the time of Sotheby's, none of them had ever traveled to the West, and few of them expected to do so. Within six months they were being flown around the world to major exhibitions in Berlin, Paris, Stockholm, Bern, Rome, Jerusalem, Fort Worth, and elsewhere. Some quickly developed strong gallery relationships

and began to earn enormous sums of money. Russian art was suddenly the hottest thing around, and though the artists still had trouble getting decent housing or studio space in their own country (real estate was fully government controlled until several years later), they were treated like royalty in the West. I went to dinners for them in Italian palazzi and French chateaux and German castles—and I also went back to see them in Russia in their cramped shared apartments and their squatters' studios.

In the late 1980s Sergei Mironenko had already made arrangements for a communal studio for a group of seven artists, and had managed to rent (through elaborate connections) a few rooms in a building on Furmanny Street. After the Sotheby's sale, these highly regarded artists were constantly traveling. Tourists from the West who wanted to buy art came to Moscow knowing only the word "Furmanny," which got them to the large building near the Krasnye Varote metro station. But the building, scheduled to be redeveloped, stood largely empty. Younger artists quickly recognized the potential of this situation, and they established themselves as squatters in the many unoccupied rooms, selling work in bulk to the eager but often confused Western visitors. By the summer of 1989, there were more than a hundred artists in the building, and the place had a sort of self-regulating structure by which it was decided who could come and stay and who could not. Most of the best artists in Moscow had studios in Furmanny, and to be there was like being in the center of the world: it was chaotic and confused, but it was where everything happened.

Though glasnost brought grand-scale Western attention to the work of Russian artists, it did not waken a comparable enthusiasm at home. The artists became famous abroad without getting even a mention in the Russian press; there was a haunting, weird quality to the way their foreign renown gave way to domestic insignificance. This was not entirely an external phenomenon. In the first years of travel and international exchange, the Russian intelligentsia, wildly excited by their new access to the West and to Western production, looked more closely at the practices of contemporary American and European artists than at what was being done in their own country. The coherence of the

Russian art world, that carefully forged international system of language and interaction bred under Kabakov, was now falling apart, and though a new coherence would later emerge, these were years of intense crisis.

In the following year, the building that housed the Furmanny studios was closed for redevelopment, and the artists scattered to several other locations. The old guard all went to Chistaprudnii Boulevard, where I found them on the day of the coup. They were joined by newer members of their circle, including such artists as Farid Bogdalov. Other young artists, including Avdei Ter-Oganian, Valerii Koshliakov, Aleksandr Sigutin, and Pavel Aksionov set up studios on Trochprudnii Boulevard. The Trochprudnii artists were part of a new generation: they were less focused on the large ethical questions that had preoccupied Kabakov and those who followed him, and were more interested in making art to show, to sell, and to resolve visual questions. "Our problem," Nikita Alexeev said to me at the time, "is that we have been preparing ourselves to be not great artists, but angels. We have been outside the ordinary idiom of art. And unfortunately, things have changed so that everyone has become an artist." The Trochprudnii artists were among the first in Russia to establish themselves simply as artists, not as angels. They sought to make work designed to function in the international and national context as visual material, without a complex moral high ground. They were also among the first to take an active interest in playing an actual role inside Russia. Every Thursday night, through the summer of 1993, there was an opening at Trochprudnii Boulevard, and the work that was shown there was always new, sometimes by one of the Trochprudnii artists, sometimes by some other young artists who had caught their interest. These Trochprudnii openings served the same purpose for the new generation of artists that the evenings in Kabakov's kitchen had served for an older generation. The new generation became the center of communication, and though the conversation was less fiercely intellectual, less boldly political, it was still communication at a very high level. Everyone went, everyone drank, everyone argued, and everyone left more excited than when he or she had arrived.

Since the coup, change has moved at breakneck speed, and the changes in the art world have mirrored the changes in the entire Russian society, which have in turn reflected changes outside Russia. Many artists now turn down invitations to travel, saying that the work they do at home is of greater importance than what they do abroad. Internationalism seemed at one time the greatest luxury, but it is exhausting to live a life of perpetual displacement, and there is a rare vocabulary you can use to address the people of your own country that you cannot use to address an international audience. Throughout the late eighties, Russian art was collected with a certain random fanaticism. In the wake of Sotheby's, a lot of collectors thought that anything Russian was fashionable and exotic, and this exoticism became a kind of joke among the artists. Turning it to their own advantage, they profited by it. There was a moment when, as a Russian artist, you could arrive in any Western city, telephone the most important gallery owners or the most famous painters, and be received immediately. Work by people of whom no one had ever heard was selling for tens of thousands of dollars. Every month or two, a museum mounted a major retrospective exhibition of the latest work of the Russian avant-garde.

Like all trends, though, this one faded, leaving behind a serious interest in Russia that was more in proportion to the accomplishments of the Russian vanguard. A small group of serious collectors has continued to travel to Russia, and some of the better Russian artists have been included in major international exhibitions. They are appreciated for the singular qualities of their work rather than for their exoticism. At the same time, the international recession and the general decline of the Western art market has meant that many Westerners who could once afford to take on the complicated and expensive business of exporting Russian art and artists to the West have had to reduce these activities. These developments have coincided with the changes in attitude in Russia. The glasnost-era romance with all things Western has subsided. People who once thought that the answers to all Russia's problems could come from the West now understand that Western principles can be put to use in Russia only if they are reconsidered, reinterpreted, and redefined for their new context. In political, economic, and social enter-

prise, Russians are focusing more and more on Russian ideas and solutions as they find that Western systems simply do not work for them. The result is a kind of liberal cultural nationalism. Russia is now much more open to the work of contemporary Russian artists, who are seen as speaking directly to a Russian audience. And this cultural openness is borne out by an increasing body of collectors. Despite the dwindling gross national product and spiraling inflation, the emergence of a substantial wealthy class in Russia means that Russian artists do not have to depend exclusively on the West for money, as they did in the past.

Galleries have played a key role in facilitating these transformations. Aidan Salakhova opened her first gallery in 1990, and since that time artists of Moscow have made much work that is oriented toward a home venue. There are now dozens of galleries in Moscow, most of them shop fronts that sell decorative landscapes and badly reinterpreted Constructivism to tourists and, occasionally, to the Russian nouveaux riches (the Russians use the French phrase), who are buying objects of all description in a sort of fiesta of mad ostentation. But there are also the serious places: Aidan's new Aidan Gallery, Marat Guelman's Guelman Gallery, Aleksandr Yakut's Yakut Gallery, Irina Piganova's Skola Gallery, and several others. In St. Petersburg there is one functioning commercial gallery of good quality. All these places show major works by artists of real accomplishment, and they function along the lines of Western galleries. Guelman in particular has introduced artists from outside the old Moscow and St. Petersburg circles, establishing interest in such intriguing young Moscow artists as Andrei Medvedev and Bogdan Mamonov, as well as artists from the old Soviet republics, including the Ukranians Oleg Golocii, Aleksandr Roitburd, and the duo Arsen Savadov and Georgii Senchenko. The other galleries have also broadened the scope of the Moscow scene. These galleries are selling increasingly to Russian private and corporate collectors, but success in the domestic market is still, in many instances, predicted on success abroad. Unlike Western artists, who usually begin at home and then go international, Russians find recognition at home most readily in the wake of foreign accolades.

The commercial galleries are complemented by a range of noncommercial spaces, all of which are perpetually struggling to stay afloat. The L Gallery, run by Lena Romashko and supported by private sponsors, has shown installations by top Moscow artists. Joseph Bakshtein's Moscow ICA and Viktor Miziano's Moscow Center for Contemporary Arts are both nonprofit spaces showing contemporary Western and Russian work, often in combination. In St. Petersburg critics, curators, and artists have rented rooms in the many old palaces of the city and have mounted an astonishing array of exhibitions in them, holding to a singularly high aesthetic standard. In general, these spaces in Moscow and St. Petersburg attract people with cultural visions or aspirations of their own. Most of the crowd that once went to Kabakov's, then to Thursdays at Trochprudnii, are now to be found at the openings at these nonprofit spaces, and if you pass by in the afternoon, you will often find friends gathered for discussion. Some of these spaces have also sponsored seminars, discussions, lectures, or performances. Russians, in memory of Communism, tend to thrive on interactive group discourse, and these spaces keep the tradition alive. At the same time, there are more and more magazines being published by the art community, and these set down the specifics of that discourse so that it will not fade from memory. *Kabinet,* which comes out of St. Petersburg, has writing of breadth and wit and originality that seem to me to be unequaled anywhere in the Western press.

In Moscow and St. Petersburg today, there is a curious mood of balance and calm. Most of the artists have given up on the slightly fantastic international life that they enjoyed in the glasnost years and have settled into serious work done for a domestic market and a small group of foreign collectors. The idea that good art embodies a moral agenda that can save the world has faded into the background. These artists are no longer directly and immediately engaged with the high mission that was their raison d'être during the days of the Soviet oppression. But that sense for high purpose of art does not perish easily. Russian society is no longer oppressive in the way it was during the Brezhnev years. The threat of the coup was put aside, but freedom is still uncertain, and every new election is an occasion for suspense. Russian society is in a state of

fragile transformation, and it is a society of increasing inequalities. Russian artists cannot help engaging in these matters. On Chistaprudnii Boulevard, on Trochprudinii Boulevard, on Granoskava Street (where one finds such artists as Olga Chernyshova and Anton Olschvang), in Afrika's studio in St. Petersburg, in the galleries of Moscow—in all these places one finds traces of that empathetic curiosity that first stirred Ilya Kabakov. At the same time, there is a sense of every-man-for-himself, a quality of competitiveness, a toughness that material advance and an uncertain future have brought. Russia is a country in which much of the population is now acting on the basis of short-term self-interest, if only because it is so very difficult to know what the long term may hold. The pictures and installations of contemporary Russian vanguard artists tell the story of their own engagement with a world in a state of relentless flux. The history of the avant-garde has been one of making something great and astonishing of circumstances of difficulty and uncertainty. "We have been preparing ourselves to be not great artists, but angels. We have been outside the ordinary idiom of art. And unfortunately, things have changed so that everyone has become an artist," said Nikita Alexeev in 1989. But in the face of radical political uncertainty, there may yet be a need for angels also in Russia. As the artists lurch back and forth among aesthetic, political, social, and moral agendas, they show a courageous energy that is very much their own. For all their flirtations with the West, they have in the end come up with a system that is very Russian. What is strongest in the work is their own uncertainty about how that system will work, whether it can be sustained, whether this high energy will save or destroy their world.

The New Russian Art Donald Kuspit

The Christian Keesee Collection of Contemporary Russian Art is a remarkable group of choice works by major Russian artists. Virtually all the works were produced in the late eighties and early nineties, during the disintegration of the Soviet empire and the re-emergence of "Mother Russia." As is well known, it was a time of great turmoil and transformation in Russia, perhaps best symbolized by a change of name: Leningrad once again became St. Petersburg. This suggests a wish to turn back the clock, as though to deny the reality of the Russian Revolution and the three quarters of a century of inhumane Communist rule that followed it. It bespeaks not only the failure of the new Russia, but also a desperate return to the values of the old Russia—a kind of ironic, typically postmodern situation. It signifies a regression in the service of the ego of Russia, although it is not clear what the outcome of the regression will be.

The situation in art is similar—equally paradoxical, postmodernist, and desperate. Just as the Russian Revolution had far-reaching effects but was discredited, so the modernist revolution—according to some scholars, the aesthetic equivalent of the social revolution, and even its prophet—had caused great change but was exhausted. Indeed, the idea of fundamental, revolutionary change was waning, inasmuch as the end of Communism and avant-gardism were serious changes. Both had become tyrannical to keep themselves from becoming obsolete as well as to tighten their hold on power, but their dogmatism

showed that they were inwardly impotent and had to be swept away. Above all, there was a strong desire to move beyond them because they did not speak to the complexity of contemporary existence. Indeed, they had tried to simplify existence, which was inherently complex.

With the collapse of the officially brave new worlds of avant-gardism and Communism, old and forgotten worlds reappeared: the styles and beliefs of the past became freshly viable and relevant. No doubt this was in part not only because the post-revolutionary future was unclear and uncertain, but also because they seemed to bring a breath of fresh expression into what had become a generally stale, directionless situation. Postmodernism rehabilitates the styles that modernism repressed, just as many people who were executed by Communism, and many ideas suppressed by it, were later rehabilitated and found to be important. Modernism thought it was possible to make a clean, "revolutionary" break with the past—James Joyce's wish to escape from the nightmare of history can be understood as a broad statement of modernist purpose—but postmodernism recognizes that it is impossible to do so, and that, moreover, the wish to do so reflects history. In a sense, modernism believed that art would be the post-religious mode of transcendence. But postmodernism regards art as a psychosocial construction that reflects history, however indirectly, in its very syntax. Where modernism thought it was possible to expunge history from art, leav-

ing a residue of pure form with supposedly unique integrity, postmodernism sees such quasi-transcendental form as itself a historical product, one that has in fact become as standard and institutional as any other.

Postmodernism is in a quandary, like Russia itself: it has a wish for a new artistic and human solidity—it wants to reverse the modern experience that "all that is solid melts," as Marx said—but it is not clear how to achieve that solidity. Indeed, postmodernism implies the impossibility of doing so, for it reflects the modern experience of dissolution. Indeed, it is the end product of modernist demystification and involution—of self-induced disillusionment with tradition. Thus, while all the styles of the past are of equal interest to it, it finds none more binding or convincing than any other. It sees through each, understands how each is constructed and works, what it means and what effect it is likely to have, and so forth. Postmodernism is therefore caught in a trap: its sophisticated knowledge of the past makes it difficult to have critical purpose in the present, for all its desire to have such purpose. This is postmodernism at its most agonizing, aware, and moral. It implies ironic nostalgia and sometimes subliminal nihilism, but it can also involve the search for a new integrity, as in fact is the case with the Russian art in the Keesee collection.

Virtually all of the art in the collection is postmodernist, often by reason of its irony, but also

because of its human concern, that is, its wish for a new integrity. There are works that reactivate old styles, traditional and modernist, and synthesize them to uncanny effect. And there are intellectually sophisticated works that tend toward nihilistic absurdity. There are works that come to grips with Russian suffering under Communism, and works that convey, through the perversity of their appropriation of past art, disillusionment with art itself, while seeming to apotheosize it. Very often the two types of works are fused.

Thus Semeon Agroskin's *Figure #6* (p. 33), 1992, is NeoExpressionist and has the bulbous sculpturality and anonymity of the Venus of Willendorf, strange as it may seem. It has the robotic anonymity of modern man, conveyed with a certain grim flair—especially the faceless Soviet man, sacrificing himself for society, that is, for the utopia, or at least the better life, the Revolution promised—and the lithic density of a prehistoric sacral object, equally anonymous. The profane and the sacred converge in the work to paradoxical effect. Agroskin's image deals with an old staple of Russian life—suffering—in a refined Expressionist manner. It deals with muted rebellion—the crossed arms of the figure make it truculent, less resigned than its slumped, rounded shoulders suggest. This wonderfully ambiguous figure—seemingly a particular individual, but also an emblem of Russian mass man, a type and social symbol—conveys both impotence and power. It sardonically plays on social realism, and as such is authentically humanistic and existentialist in import, unlike social realism, which makes a farce of human existence. It seems to epitomize the mood of the Russian masses on the verge of revolt against the Communist dictatorship.

The strong, deceptively simple figure, embodying both misery and anger, is decontextualized in a way that makes it seem all the more absolute and ominous. It virtually fills the canvas, and confronts us by pressing against the picture plane, almost breaking it. This shows that the figure can still make universal expressive sense, as well as convey the outlook of the society in which it is made. Agroskin's image is important because it shows that it is possible to make post-ideological existential-humanist art in Russia—a sign that the individual counts, not just the collective.

No doubt my interpretation of the figure will be unacceptable to the artist—he regards it simply as a study in form (one of twenty painted monochromatically, some with different colors)—but, in line with postmodernist thinking, it cannot escape history and actual existence. It connotes them with a vengeance despite itself. Agroskin offers us a generic figure that, through its contradictoriness—it is simultaneously an image of humanity and a purely formal device, a representation and an abstraction, a recognition and a projection—conveys the pathos of both life and art in contemporary Russia, by reason of their long repression.

Farid Bogdalov's *Dominoes* (pp. 42–43), 1992, is more obviously postmodern in its mix of stylistic quotations. With true postmodernist egalitarianism or pluralism, Bogdalov appropriates Warhol's Marilyn Monroe, a detail of a Pollock all-over painting, a Malevich Suprematist square, a violin that looks like it has been destroyed à la Arman, all of it "integrated" via Minimalist seriality. It too deals with a kind of suffering: that of art, unable to have any priorities, to establish a hierarchy of values. The final result is powerfully and elegantly conceptual, by reason of the various undecidable contrasts it sets up: for example, between Malevich's black square and Warhol's gold square (black is the color of the anarchist flag, gold the color of capitalism), and, perhaps most ingeniously, between Pollock's dark linearity and that of the Russian language text. The whole thing is a kind of concrete visual poetry made of images that have become prosaic. Connotations proliferate perversely, but the most important connotation—and denotation—is that conveyed by the title: art has become a game of dominoes, and, like dominoes, one piece can take another piece and all the pieces can fall down.

In other words, Bogdalov conveys, with splendid intellectual irony, the nihilism of postmodernism. Making art is not only playing a game, but also a kind of one-upmanship in which each artist tries to outplay—outgun?—the other, but none ends up ahead of the other, that is, qualitatively any better or intellectually more meaningful than the other. Bogdalov's piece is brilliantly entropic and absurd: it articulates the seeming dead-end, yet endless proliferation—it is a claustrophobic labyrinth in all but name—of an art in postmod-

ernism. He creates a system whose parts can be rearranged at a moment's notice, but which remains essentially the same, as does each of its parts: all are ironic Suprematist squares. Not only is one modern image as good as any other, but one traditional image is as good as any modern image. There is an abundance of art—and Bogdalov seems to be appropriating previously avant-garde American and Russian modernist art in part to suggest that Russia can become as affluent a capitalist society as America, and that art can become as important a commodity in Russia as it is in America—but it is not clear what it all means. Is it simply a symbol of the success of art, and its mass (over?)production— for many other works could have been juxtaposed—in capitalist society? Bogdalov's work is a tour de force of appropriation in art, and seems more conscious of the ironies of postmodernism than most of it.

Similar in spirit to Bogdalov's work is Avdei Ter-Oganian's *A Page from a Hungarian Album (After Malevich's An Englishman in Moscow)* (p. 115), one of a large series of "museum pieces." It is an inaccurate copy of a pre-Suprematist Malevich painting—a copy that ingeniously reduces the original to nonsense. Imagining himself a provincial artist making his first encounter with modernist art, he turns the exciting experiment into a tame replica of itself. Modernism is no longer outlandish and disruptive and revolutionary, the postmodernist Ter-Oganian suggests: its experimental works have become certified masterpieces in museums, establishment works copied by students the way Renaissance and Baroque masterpieces are. Academically legitimate, modernism has become a cliché that students learn to ape, however badly. Malevich's work has no inner meaning for the naive student; it is simply a technical problem—a difficult formal exercise— to be mastered.

Inessa Topolskii's *Dr. Thulp's Anatomy Lesson* (p. 119) is similar in intention to Ter-Oganian's piece. Like the Starn twins, Topolskii melodramatically dismembers a masterpiece, but in her case it is one she meticulously repaints rather than photographs. The dramatic scene by Rembrandt is ironically fragmented. It has become a Humpty-Dumpty that has had a bad de-Constructivist fall and cannot be put back together again. Topolskii's antipicture is pro-

23

foundly skeptical—a true piece of appropriation art in that it negates what it appropriates. It is full of disbelief, irony, wit—especially by reason of the eloquently matter-of-fact flurry of gray gestures that cover the metal ground for the Rembrandt relic, which is magnetically attached to it. Furthermore, the pieces of the puzzle can be juxtaposed and rearranged at will, to generate absurd new effects, whose meaninglessness confirms the fact that the Rembrandt masterpiece has lost its meaning or has been emptied of meaning by its nasty appropriation. Topolskii's work is a postmodernist masterpiece in its own right.

Bogdan Mamonov's *Portrait of an Unknown Man* (p. 77) is another appropriation painting. The man is, of course, not unknown: he is Mao, whose celebrated face is as banally familiar as that of Marilyn Monroe, another star. Warhol reduced both figures to decorative pointlessness by his appropriation of them—or rather confirmed the decorative pointlessness their faces already had become in society—but Mamonov makes a certain political point by putting Mao in a nineteenth-century officer's uniform and posing him in a quasi-classical manner against a traditional landscape: the ostensibly proletariat Mao was really just another military aristocrat. Indeed, the radical becomes self-trivializing by becoming the radically chic. By dressing Mao in a reactionary royalist uniform, Mamonov strips him of his revolutionary disguise—debunks him. He was in fact a Communist king in all but name. Thus, there is a profound social realism to Mamonov's ironical picture.

Igor Nezhivoy's *America* (p. 87) appropriates Grandma Moses' naive, folk landscape style and deals with colonial America's history. Georgii Litichevskii appropriates comic book style to tell a story about the relationship of *The Critic and the Artist* (pp. 68–69), in which, of course, the critic betrays the artist and is made to look like a fool. What is really of interest in both of these works is their use of populist, readily communicative, narrative—really anecdotal—styles. In contrast, Arsen Savadov and Georgii Senchenko's *Paradise Lost* (p. 99) and Aleksandr Roitburd's *Contemporary and Classic Art (Portrait of the Artist as Caravaggio)* (pp. 96–97) appropriate traditional styles to make allegorical statements. While also easily readable, they have a self-reflexive subtext:

they are about the dilemma facing the postmodernist artist. Should he or she be contemporary or traditional, or a combination of both?

Savadov and Senchenko suggest the latter, by way of their conceptualization of the nineteenth-century image they appropriate. It is recontextualized on a gold ground and surrounded by ropes tied in various nautical knots. They at once formally echo and ironically mock the figures of the damned, who are literally and figuratively "at sea": their bodies are tied together and their tormented spirits are twisted in suffering. Savadov and Senchenko do something similar in *Swan Lake* (p. 101): they "ironicize" traditional Russian ballet—indeed, the most famous Russian ballet—by painting a scene from it on a modern Red Army canvas tent. The juxtaposition, which has all the brevity of great wit, not only suggests the contradictions of Communist society, but also shows the power on which Russian culture rests—culture as an ideology disguise of brute force. In the Roitburd the dilemma of the title is reflected in the fragmentation of the traditional scene, which makes it contemporary. The angel, who seems less inspiring than skeptical, epitomizes the dilemma with the gesture of his exaggerated finger. Caravaggio was, of course, also faced with the dilemma: he modernized—vulgarized—religious scenes by using contemporary, indeed, everyday figures in a melodramatic way. Was he an unwitting postmodernist, in attitude if not historical position? He, too, was an epigone, struggling to use what was stylistically given to make new expressive sense—to find new solutions to old expressive problems.

Sergei Sherstiuk's *The Letter* (p. 107) is also postmodernist and ironical, in both its photorealism—he was a founding member of the hyperrealist Group of Six (1980-85)—and its surrealist inspiration. It is a literal rendering of a chapter on "How to Write a Letter on Your Head While Looking in the Mirror" in a surrealist book. The absurdity of the act is banalized by its literal illustration. It loses its unconscious meaning and becomes simply a technical feat. Sherstiuk illustrates many chapters from the book, yet he is aware of the unresolvable discrepancy between the verbal and visual texts, which suggests the absurdity of trying to translate one into the other. The floating bottle—"the kind you might stuff with a note and throw into the ocean," says the artist—signifies

this dilemma: "It would be as easy to understand the original book as to hope to find a real explanation in a bottle washed up on a distant shore." In other words, *The Letter* is a note that actually explains nothing about the surreal act described in the book, let alone about the book as a whole, however close it comes to doing both. Does Sherstiuk's hyperrealist rendering of a surrealist act strip it of meaning or make it more enigmatic? We are again in a situation of postmodernist undecidability and nostalgia—nostalgia for modernist surrealism, which may be a meaningless, empty gesture, and so truly absurd.

Valerii Koshliakov ironically repaints, with a kind of faux Expressionist flurry of drips and gestures, photographically familiar images. *Portrait of Hermes* (p. 65) and *Soviet Square* (p. 63) are profoundly skeptical, tongue-in-cheek works. The chance drips are apparently the result of house painters working on the ceiling of his studio while he was absent. Koshliakov had forgotten to cover his canvas; on returning to his studio, he found the "result" pleasing and declared his picture finished. This, of course, is an ironical modernist gesture, familiar from Duchamp, whose *Large Glass* was finished by chance, as he said. (It accidentally broke.) Koshliakov uses the chance drips to mock—"break"—his "perfect" subject matter. He wanted to make a "perfect representation." The drips are a heavy, ironical dose of imperfection, undermining the idea of representation as well as perfection. For Koshliakov both are inseparable from official art, Russian or otherwise. His "casual" art is a nihilism critique of it, in the best postmodernist manner (or mixing of manners).

Gia Abramishvilii's *Private Collection* (p. 29) is yet another ironical postmodernist work. A triptych repetitively depicting a jar of paint and a brush on top of it, as though they are a coat of arms (which can be ironically understood), it mocks painting itself as well as collecting. The first panel is red, the second yellow, and the third green. Each is painted with the same eloquent smoothness. Painting has come to a self-referential dead end in these paintings. It is reduced to illustrating its own means.

Sergei Mironenko's *Goodbye* (p. 83) also uses an illustrational technique to debunk. In it a kind of fairy princess—the image is one of a series

appropriated from various nineteenth-century books of "ladies"—sits on a Communist sickle which becomes a golden moon (set against a passionately alive night sky). The ironic nostalgia of the work is rich with meaning. The allure of Communism has been made into a farce. Like Mamonov's Mao piece, the work debunks a myth—plays a joke on Communism. Like most of the postmodernists, both use illustration strategically and ironically, as well as to hide underlying bitterness. Russian life is some kind of crazy joke or absurd farce, they suggest, on a personal level—as Andrei Yakhnin's *Short Stories* (p. 123) indicates—as well as on a political level. Yakhnin paints pages from a novel he is writing about the inhabitants of his apartment building, all of whom have "fascinating" lives. In the two-part Keesee collection piece, we see a man writing with his hand and with his foot. Exploring the North Pole, he has just lost his hand to frostbite, and has taught himself to write with his foot.

To me Ivan Kolesnikov's *Searching Mechanism that Eats Himself and Is Triumphant in Finding It* (p. 61) is a particularly telling example of the "insanity" and irony of Russian existence. (In a sense, it was always postmodern in spirit, however much at a certain moment it may have wished to be modern.) Slyly surreal, the work shows "a piece of birthday cake that is tired of being cake and wants to change itself into something more organic, like a landscape. It begins to conceive of this idea and then it proceeds to happen." In other words, the picture shows a dream coming true. It is an ironical wish fulfillment—a compound irony, so to speak, for the artist himself is a piece of birthday cake. In Russia, life is a piece of cake or a lovely landscape—in fantasy. The "secret" of the picture is the behind-the-scenes blueprint section of gears in the final image: life in Russia is really rather mechanical. The cake is painted beautifully but repetitively, so that it finally becomes banal, even when it turns into a landscape, which turns out to be peculiarly anticlimactic.

Is there no reprieve from the relentless irony, the relentless debunking attitude of postmodernism that plays so well into cynicism about Communism and life under it? Little, it seems. Reprieve certainly does not come from Afrika's *Under the Cover of Reunification* (p. 47), which scrambles the surface of a social realist image, in effect debunking it, without denying its heroism. The postmodernist contradiction is confirmed by the illustrated vegetables in the left corner, taken from a children's storybook. It undercuts the narrative as much as the vigorous expressive handling. In a different but equally debunking vein, his *rebus III* (p. 45) uses symbols derived from a child's game to suggest that art is a child's game—a puzzle which must be deciphered, but to what point is not clear.

Natasha Turnova's witty *Lenin and Tolstoy, What to Do?* (p. 121)—presumably about Russia in its present crisis—is skeptical about both politics and literature (symbolic of art as such). Turnova shows Lenin talking to Tolstoy about his second book, *What Is to Be Done*. "What to Do" is an abbreviated version of the title that has become an exclamation of despair used by Russians about the problems of daily life. Both Lenin and Tolstoy tried to solve the problem of Russian society, the former offering a realistic solution, the latter an idealistic solution. Both solutions were unworkable and, indeed, created more problems than they solved. The bright, slapdash, childlike painting—a sort of vulgar, comic Fauvism—suggests that the Russian "vision" of society has become a bankrupt joke. That is, the work suggests that Russian society is an insolvable problem, for even the greatest Russian minds have been unable to solve it. At the same time the humor and colorfulness of the piece implies that there is hope for Russia. Such ambivalence is no doubt to be expected in the current state of transition.

Russian fantasy comes to the rescue, although it does not really offer an escape from the reality of Russia, only a way of expressing one's feelings about it. The Keesee collection has some important contemporary examples of Russian fantasy art. Olga Bulgakova's *Dwarfs* (p. 48) is a surreal dream picture. A naked woman, passively sitting with her eyes closed, seems to be under the spell and dominance of a red devil. (Many of the characters in Bulgakova's scenarios are similarly posed, suggesting that they are turned inward and blind to outer reality.) The dwarves cavort, often violently, in the lower foreground, almost like a medieval commentary on a main scene. Do they represent her feelings and thoughts, given free rein while her body is hypnotically immobilized? Particularly striking is the red wine that pours from the table onto the palette, on which the female figure—implicitly a self-portrait—rests her foot. I read the picture as an allegory of art under the Communist devil—an ironic "muse." (The muse interpretation seems to me confirmed by the bird—a traditional symbol of the soul—on the devil's shoulder.) The artist is inspired, but perversely. The lurid, all-pervasive red is at once sensual and aggressive, conveying intense instinct as well as a symbol of Communism. No doubt the red devil is an inner alter ego—a private devil—but it also has social resonance.

Perhaps a Russian interpretation does not tell the whole, very personal story of this beautifully painted picture, but Russia is alluded to explicitly in many other fantasy works. Thus Andrei Filippov's *Ultima Thule (Artists in the Same Direction)* (pp. 52–53) poignantly deals with the myth of Russia as the Third Rome (after ancient Rome and the Holy Roman empire). The irony is that Russia is really the Ultima Thule beyond the seven hills of Rome—the cold, barbaric land beyond the warm Mediterranean civilization that Rome was. The picture meticulously records an event: the artist, drunk one evening in the Crimea, goes in search of Ultima Thule with a friend. Filippov accidentally broke his leg, and his friend carved, out of branches, two crutches to help him back to the city. The painting is an homage to the friend. The mythical Ultima Thule is depicted in the background, its name an ironical, ghostly stencil above it. The letters of the title are equally ironical, composed of a series of miniature double-headed eagles, a symbol of empire dating back to ancient Rome. The wooden crutches frame the morbidly blue night scene, giving the work an ironical conceptual edge, like the accident itself. The cool execution only confirms the isolation of the artist and his friend in a dream of what Russia could have been—the greatness that might have been, and once was, but not in Russia. It is a fantasy full of the futility of contemporary Russian life in particular and Russian history in general, as well as of the crippling of the artist in Communist Russia. His spirit was broken as his legs were. Nonetheless, the blue is an old (Christian) symbol of hope, and no doubt a conscious alternative to the oppressive red of Communism.

Oleg Golocii's *The Languor of Oedipus* (p. 55) is a morbid fantasy of that mythical figure's

25

self-blinding, strongly painted in an Expressionist vein. There are, after all, paintings that deal with general human issues—that escape the obsession with Russia, under Communism and in general. (And, as we will see, there are also abstract paintings that are simply very good paintings.) Andrei Karpov's *Four Types of Memory* (p. 57) is a literal rendering of the theory that the brain remembers in sequences of importance. For example, we first remember places and scenery, then people, then important people next, and finally ideas. But whatever its conceptual significance, Karpov's painting is lyrical and childlike, as his *Self-Portrait* (p. 59) is relaxing—full of a remarkable joie de vivre for the usual melancholy Russians (virtually all the postmodernist conceptual-critical works mentioned are profoundly melancholy, however tempered by irony). Karpov is the unofficial leader of a group of artists who paint in a similar "Primitive-Expressionist" style, as it has been called. (Igor Nezhivoy's *America* is in the same style.) Formerly a scientific researcher, Karpov is clearly as much of a visionary as Filippov.

Natalia Nesterova's *Tightrope* (p. 85) is equally lyrical if more somber in character. The Yiddish word "balance" written on the performer's umbrella suggests that the work is a political allegory. Perhaps the acrobat is a Jew keeping his or her balance on the tightrope of Communist society. No doubt it is also an allegory of the artist in the same precarious, poignant situation, as in Filippov's work. Andrei Medvedev's *Lament of the Dolls* (p. 81) and *The White Officer* (p. 79) are surreal as well as lyrical and also have a subliminal political message. It is Russia that is lamented, and nostalgia for White Russia is expressed—the last a particularly astonishing, daring idea in post-Communist Russia. Ter-Oganian's *Never Say Never* (p. 117) expresses something similar: ostensibly a still from a James Bond movie, the

figures are implicitly KGB agents, but the city is European, as the Dunlop sign suggests. There is an alternative to Communism. Vasilii Shulzhenko paints his dreams, and *The Philosopher* (p. 109) is a kind of dream self-portrait. He says he dreamt of a man being chased through a church by monkeys. (The icons are hanging on the wall of a church, and a procession moves in the opposite direction to that in which the philosopher is going.) But the work is yet another political allegory: the sacred church is profaned by the Communist monkeys, who torment the philosophical artist. He is, incidentally, walking a plank in a prison cell, no doubt the prison cell of his mind but also of Russia. Again, the dilemma of Russia is expressed, this time through an existential fantasy rather than through the dilemma of postmodernism. Indeed, Shulzhenko represents modern Russians who cope with the difficulties of daily existence. These difficulties are clearly enormous.

Almost all the works in the Keesee collection suggest as much, masking their Russian pathos with postmodernist cleverness or surreal wit and fantasy. But the collection also shows that abstract art exists in contemporary Russia, hanging on to the formal "truth" of painting by a slender yet strong modernist thread. Sometimes it is vigorously gestural, as in Badri Lomsianidze's and Roland Shalamberidze's paintings, sometimes it is subtly geometrical, as in Eduard Shteinberg's *Composition, December,* (p. 103) which is in part a "metaphysical," Neo-Constructivist reprise of El Lissitzky. Ivan Olasuk's untitled abstractions, blending a loose, sketchy spatial pattern and rhythm with a densely textured—almost impacted—surface are my personal favorites, along with Timur Novikov's *Symbols of Water, Earth and Air* (p. 89). It shows not only sensibility, but also a symbolism that reminds us that even in self-obsessed Russia it is possible to make an intimate art that crosses all borders.

Taken together, the works in the Keesee collection make several important points: (1) that painting is still alive and well in Russia as in many other countries; (2) that painting can be put to "conceptual" use, as in the case of the best postmodernist paintings, particularly those made during the eighties in Germany and Italy; (3) that like much conceptual painting, it is ironical about social reality without being bitter, and introverted without being inaccessible; (4) that it is subliminally humanistic, also like the best of German and Italian painting of the eighties. The New Spirit of Painting exhibition that was shown in London and Berlin in 1981 heralded the new internationalism as well as the new conceptual painting of the eighties. Indeed, the emergence of painting as a conceptual art is an important achievement of postmodernism. Since then, international painting has become a fact of artistic life. By international painting I mean not just important painting made in different countries, but painting that draws from different styles that have become internationalized, that is, generally credible, to the extent of forming a transnational synthesis of style. Thus, while the Russian painting in the Keesee collection often reflects Russian interests and iconography, social reality and temperament, it also makes an important contribution to international art and the new transnational style which I think is a positive contribution of postmodernism. The new, post-Communist Russian art is cosmopolitan—open to international influence, indeed, it holds its own and contributes internationally—as well as Russian. As such, it suggests that Russia is ready, willing, and able to participate in the world community, transcending the xenophobia and paranoid suspiciousness that characterized it under Communism.

Collection

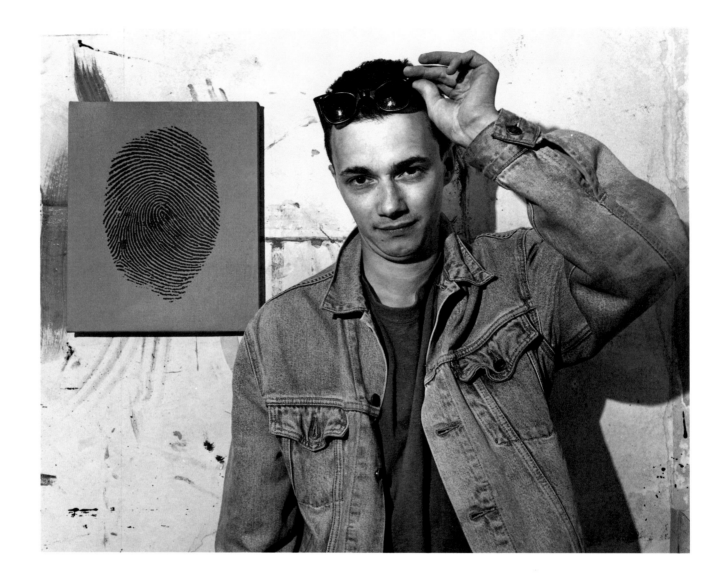

Gia Abramishvilii

"The triptych of paint jars is from a series of canvases I was producing while I was trying to investigate the consciousness of human beings before it becomes artificial. The jar of paint and the brush represent the materials of art before they are used—consciousness before it is influenced. Art at the beginning. The first title I gave the piece was *Clear Water Is Transparent*, but I thought it seemed too ambitious. *Private Collection* simplifies it. It's like *Installation View* or *Courtesy of the Artist*, it's the vocabulary of art."

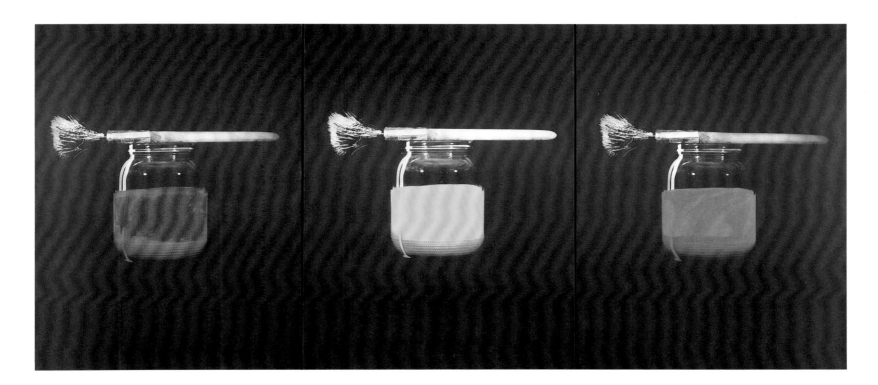

Private Collection, 1990
Photo linen with silkscreen acrylic triptych, 39-1/2″ x 88-1/2″ overall

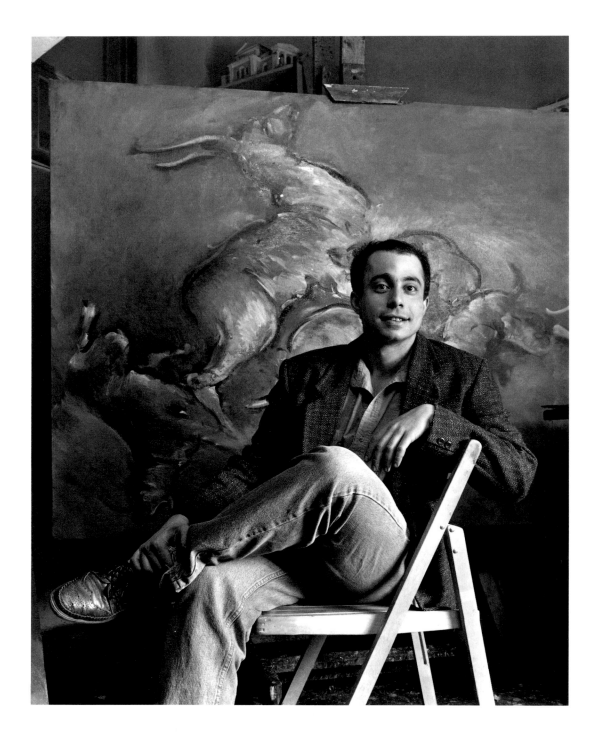

Semeon Agroskin

"My inspiration for this particular series on animals and the hunt came from sketches on boards produced by Flemish artists in the 17th century and as ideas for tapestries. I saw them in the Hermitage Museum in St. Petersburg, but they were unfinished. Just drawings without color. My idea was to finish them with my own interpretation. Historically, death in such hunting scenes has been portrayed beautifully, but I wanted to remove what I considered to be all unnecessary figures like the hunters themselves, so that only the 'central' figures remain. I added color to the sketches, yet kept the feeling of a work in progress."

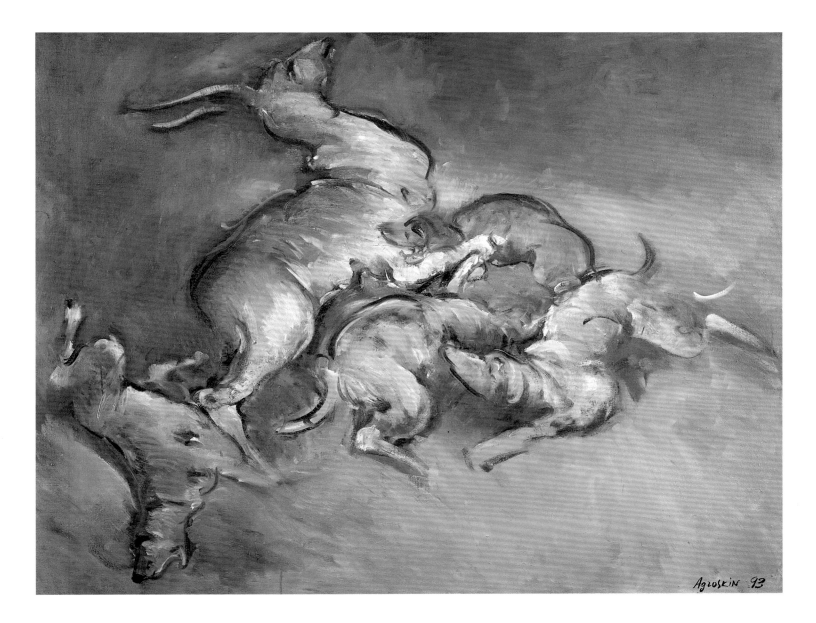

Hunting Antelope, 1993
Oil on canvas, 54-1/2″ x 70″

"There are roughly twenty paintings in the *Figures* series. In using the figure as a subject, I wanted to find something fundamental in everyday life. I was looking for something common to us all. The actual postures represent people standing in the street, sitting on the subway, walking, or just in everyday situations. In looking for that gesture that can be found in all of us, I chose not to represent detail. An expression on a face doesn't last very long, but a gesture is repeated. The color of the paintings is monochromatic as a response to a certain kind of dull light."

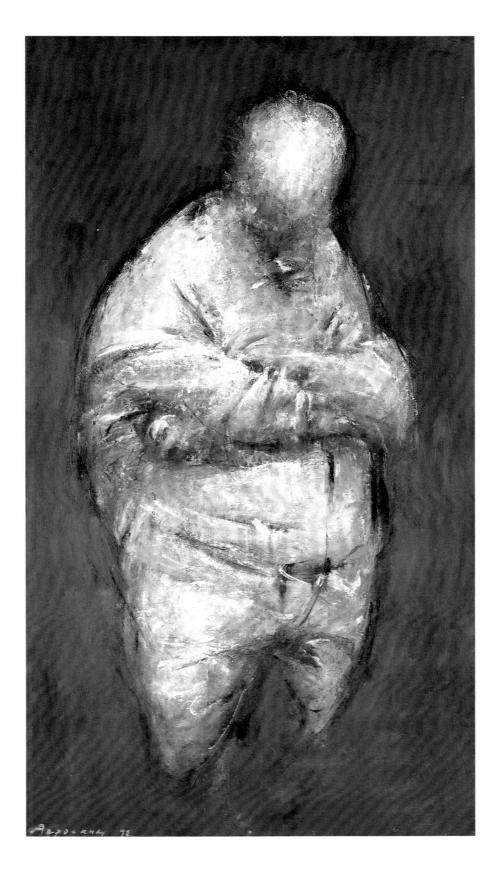

Figure #6, 1992
Oil on canvas, 67" x 37"

Yurii Albert

"When I began this series, the title of this piece was *I Am Not Andy Warhol*. I made other paintings in the style of other artists and titled them *I Am Not Jasper Johns* or *I Am Not Roy Lichtenstein*. But I'm not so sure anymore. I may be more like those artists than I thought, so I now call it *Self-Portrait Like Another Artist*."

Self-Portrait Like Another Artist, 1991
Acrylic silkscreen on canvas, 67-1/2″ x 67-1/2″ overall

Nikita Alexeev

The words at the top of each of Nikita Alexeev's paintings are taken from Russian poetry and do not have a literal translation.
The absurdity of the titles, *The Star with 5, 6, 7 Ends, Which Is More True, When More Sugar?* and *Warm Hands and Empty Heart,*
Stereo in Eggs in relationship to the images is reminiscent of Dada experiments by such artists as Jean Arp and Max Ernst.

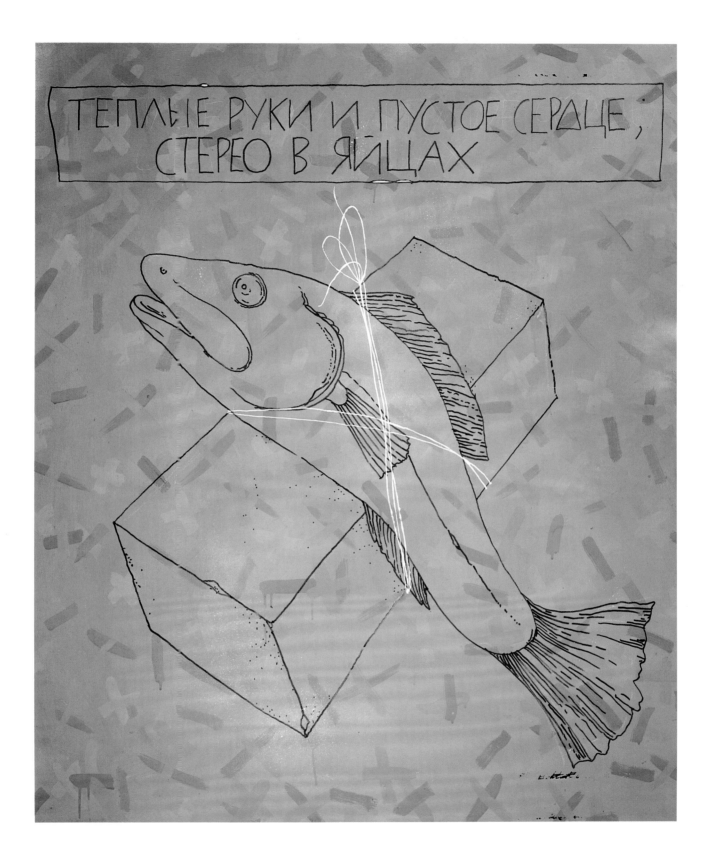

Warm Hands and Empty Heart, Stereo in Eggs, 1993
Oil on canvas, 58-1/2″ x 46-1/2″

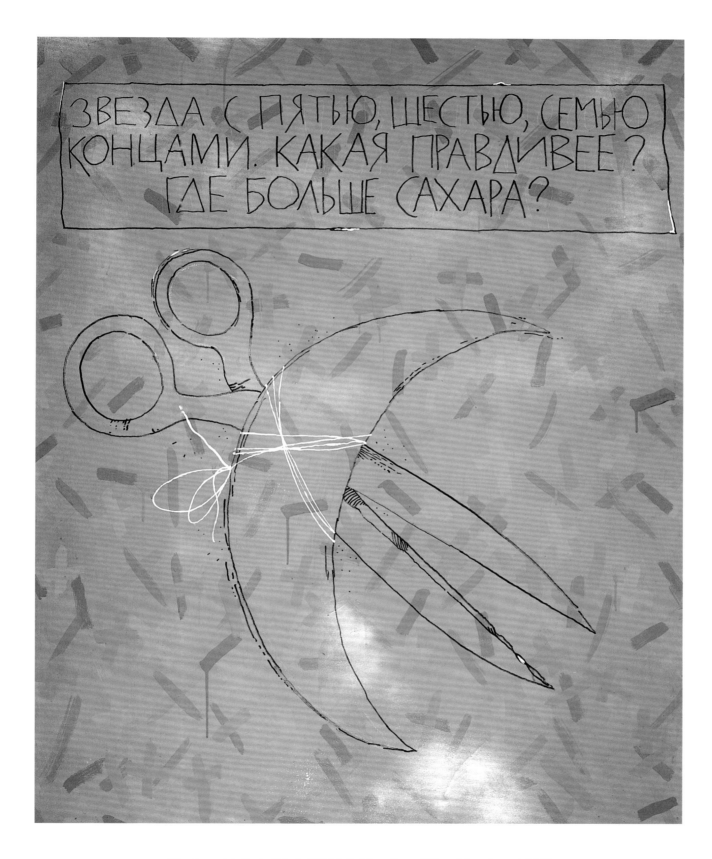

The Star with 5, 6, 7 Ends, Which Is More True, When More Sugar?, 1992
Oil on canvas, 59″ x 47″

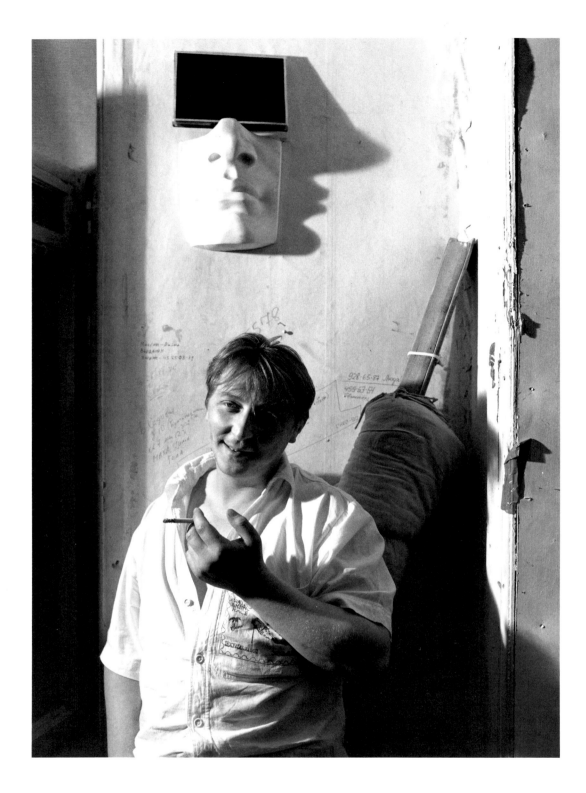

Farid Bogdalov

"There are four categories of artists; those who believe in art as a tradable commodity, those who believe in pure art, those for whom it is a game, and those who feel it must have a theme. I don't share any of these beliefs and I share them all! *Pallets* represents art as a commodity, the pallet itself being necessary for production. *Dominoes* represents art as a game. What is painted on each piece within the installations represents the iconography of Western art."

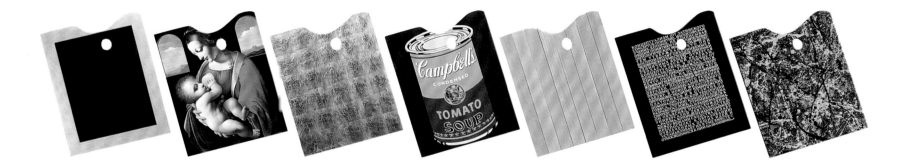

Pallets, 1993
Oil on board, lacquered, each pallet 16″ x 20″

Dominoes, 1993
Mixed media, 28 individual pieces, each piece 9-3/4″ x 19-3/4″

игра - форма свобод-
ного самовыявления
человека, которая пр-
едполагает реальную
открытость миру воз-
можного и развёрты-
вается либо в виде
представлен-ия (испо-
лнения, разыгрывания
сценария, либо в виде
к-л ситуации, см
нии) к-л состоянии. Це-
лый ряд влиятельных
направлений совр. м

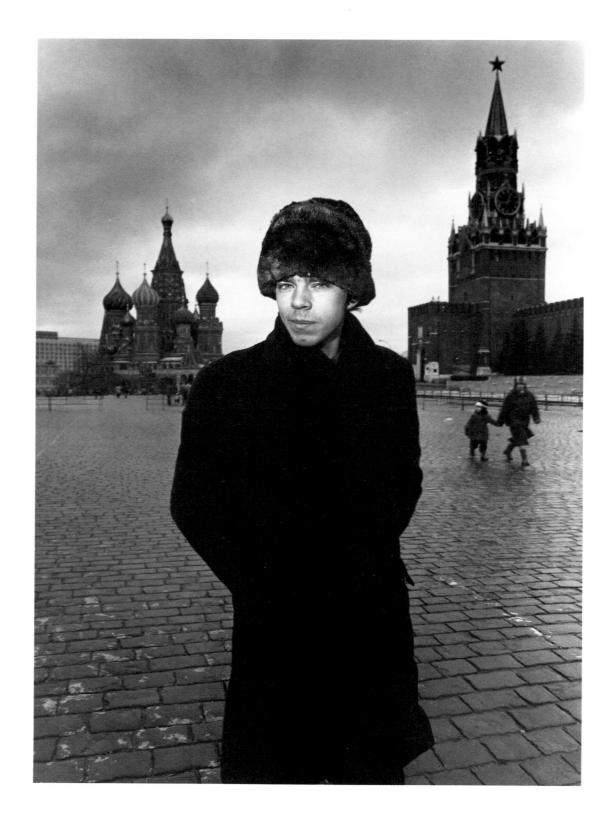

Afrika

"In 1982, we had the first exhibition in Moscow of the work of Andy Warhol. And for the Russian people, there was no way in which to relate to his Campbell's soup cans. For the American people, it's an icon, a code perhaps, part of a social structure. But obviously, the code is different here, so I must use my own kind of imagery. My rebus pieces are symbolic really. They are part of a game which consists of asking questions and giving the imagery, then getting some kind of answer back from the other side."

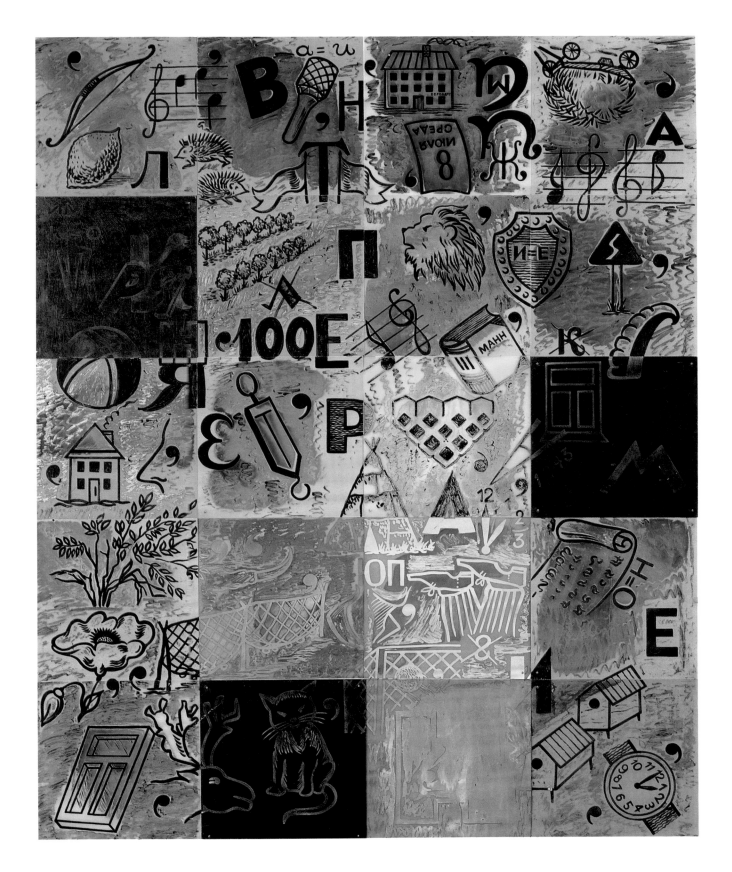

rebus III, 1992
Oil and silicon on etched plates, 80″ x 64″ overall

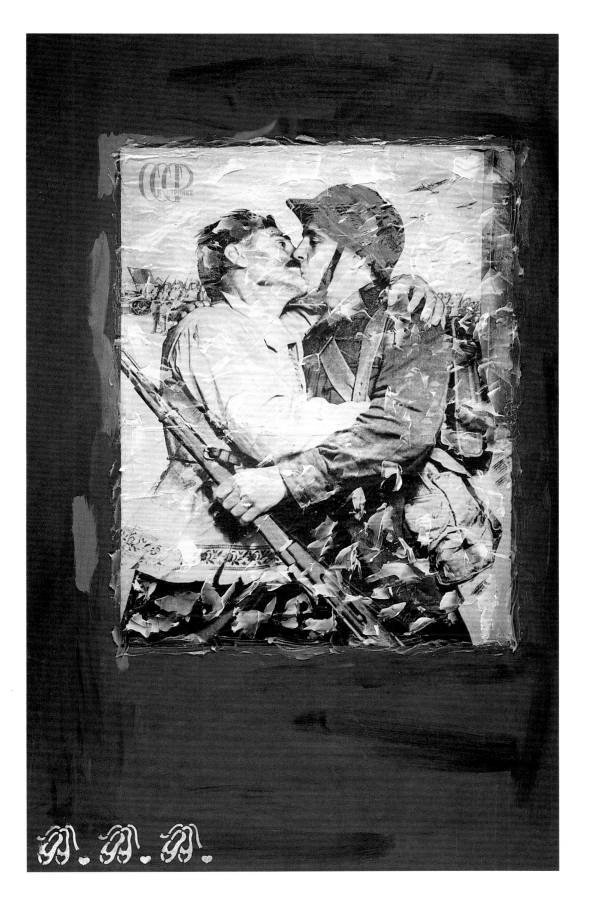

Under the Cover of Reunification, 1990
Acrylic, rubber paste and photo textile on canvas, 80″ x 49-1/2″

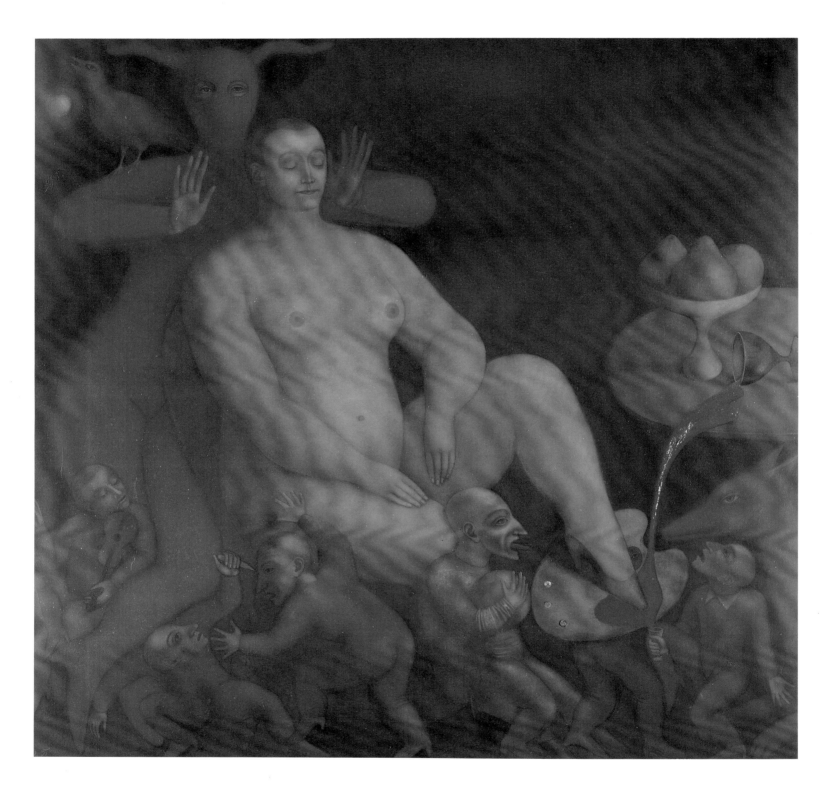

Dwarfs, 1992
Oil on canvas, 65-1/2″ x 67-1/2″

Olga Bulgakova

"There is an ambiguity about my painting *Dwarfs*. The figure standing behind the seated woman is a mystery figure. No one can tell really what he represents. Maybe he's a jester, maybe a hangman, maybe a combination of both of these creatures. In a way, he serves as a backdrop for the central figure. The dwarfs, on the other hand, have a life of their own. They have their own revelry or quarrels amongst themselves. But the central figure, she's calm. She is beyond them all. She doesn't notice them and cannot see the figure in back of her either. It's all still very much a mystery."

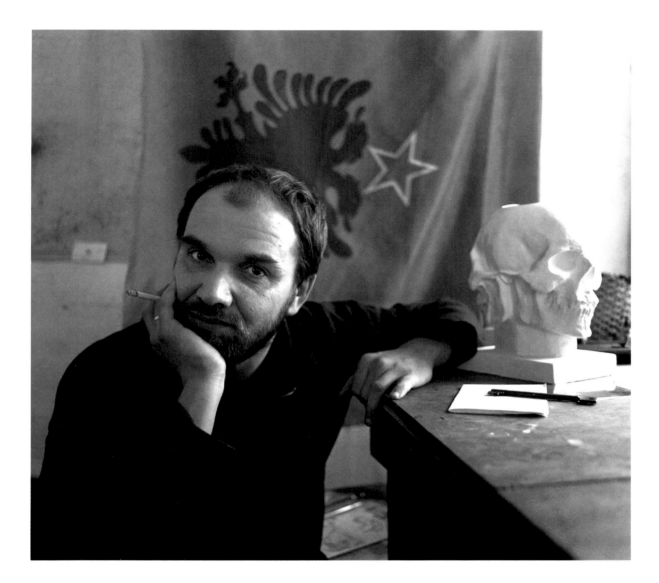

Andrei Filippov

"I went to the Crimea with a group of friends, all artists. We all drank a lot and went looking for
the mythical city of Ultima Thule. It comes from a legendary story entitled 'The Place We Couldn't Reach.'
We wandered out of the city in search of this place which of course only exists in our imagination, and I fell and broke my leg.
My friend had to help me, and he fashioned the crutches out of the branches of trees and our own sweaters and together,
we made it home. I painted *Ultima Thule (Artists in the Same Direction)* as a tribute to my friend."

Ultima Thule (Artists in the Same Direction), 1992
Oil on canvas with two carved wooden crutches
Canvas measures 38″ x 117″, crutches approximately 5 feet in height

Oleg Golocii's life was tragically cut short
and photographs of the artist were impossible to
obtain following his death.

Oleg Golocii

Oleg Golocii was a bright and artistically gifted young man whose life ended in 1993. A member of an informal group of artists from Kiev, all involved on some level with Neo-Expressionist painting, he had established a following in Moscow art circles and his work had been shown in numerous exhibitions in Europe in the late 1980s. The subject matter for much of his art was drawn from biblical and mythological sources and often depicts troubled characters. It has been suggested that his paintings echoed his own personal struggles.

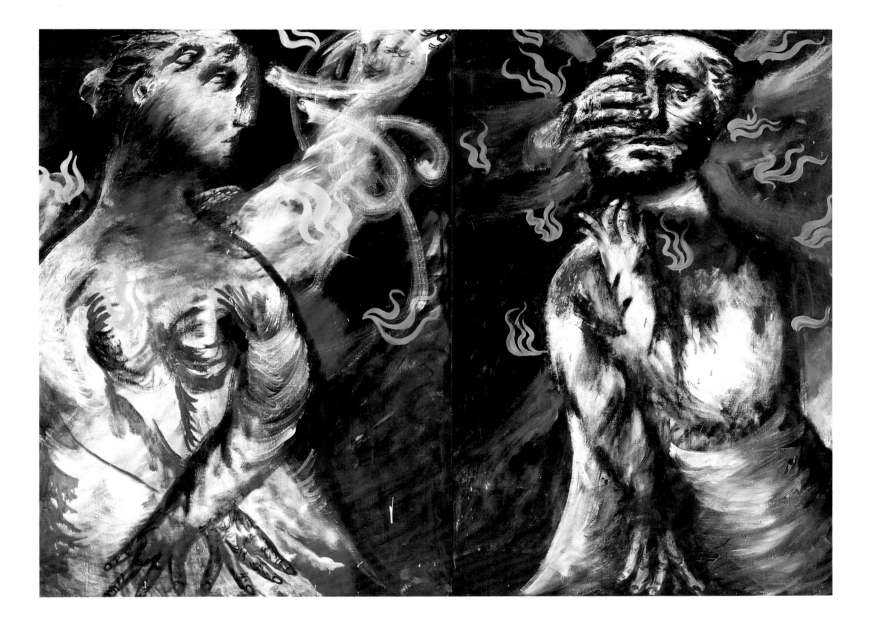

The Languor of Oedipus, 1989
Oil on canvas diptych, 77″ x 108″ overall

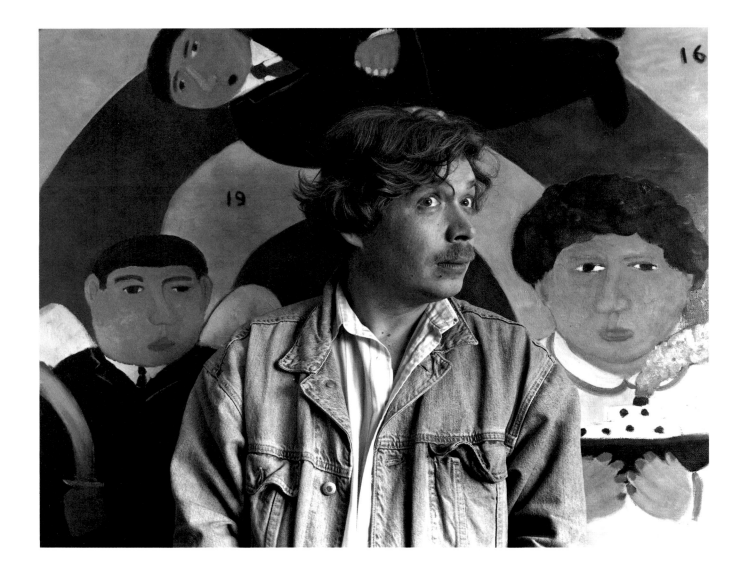

Andrei Karpov

The term *Primitive Expressionist* could easily be applied stylistically to Andrei Karpov (one is especially reminded of the work of Mikhail Larionov), but that would be literally too limiting a description of the individual who studied science, pursued biological research, and ultimately became a painter. In one sense, his art continues to function as research into the complexities of everyday life. In *Four Types of Memory,* he describes visually a theory that proposes an order and attributable importance to the way in which we think. Then there's *Self-Portrait,* which obviously belies our image of the scientist.

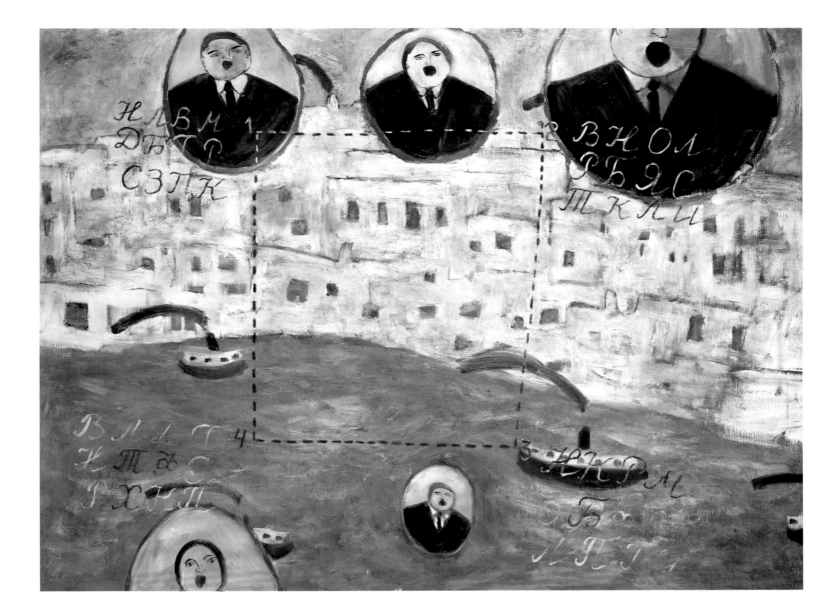

Four Types of Memory, 1992
Oil on canvas, 58" x 77"

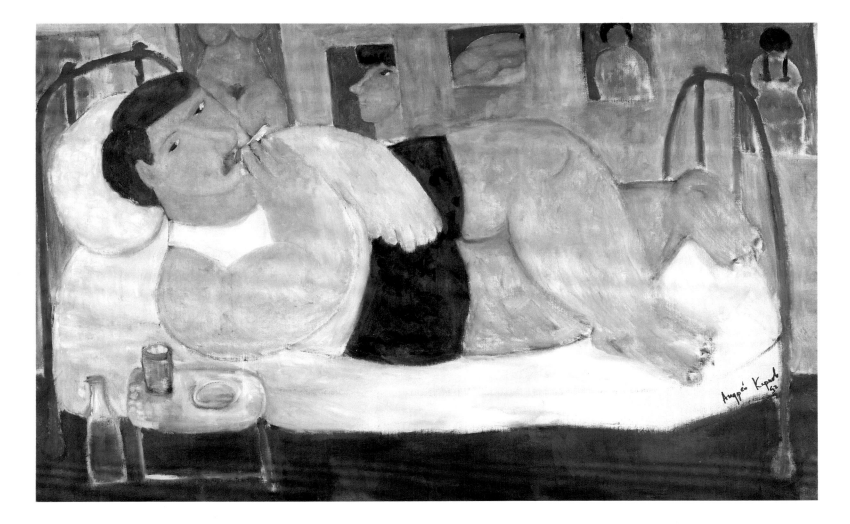

Self-Portrait, 1992
Oil on canvas, 47″ x 78″

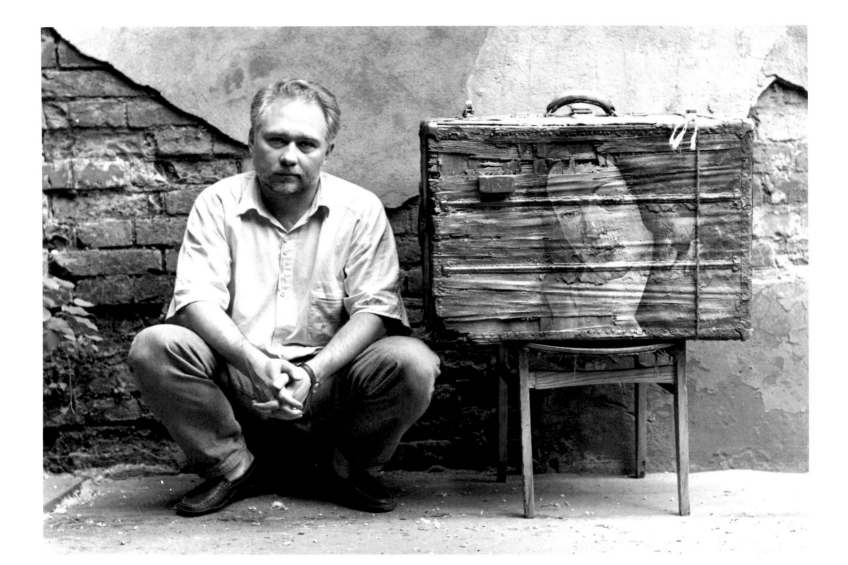

Ivan Kolesnikov

"*Searching Mechanism That Eats Himself and Is Triumphant in Finding It* is not a complex painting. Imagine, if you will, a birthday cake that is tired of being a cake and wants to transform itself into a landscape. It is a long process, but can it be successful? Who knows?"

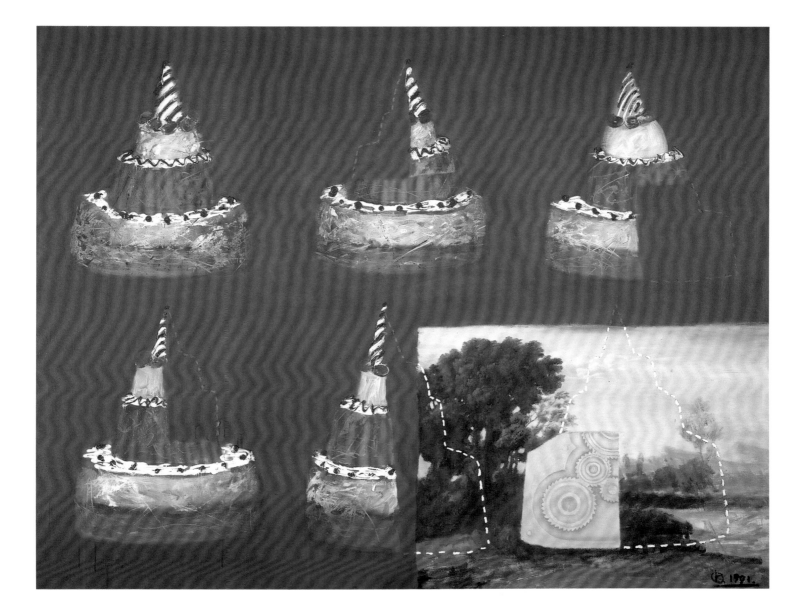

Searching Mechanism that Eats Himself and Is Triumphant in Finding It, 1991
Oil on canvas, 50-1/2″ x 63-1/2″

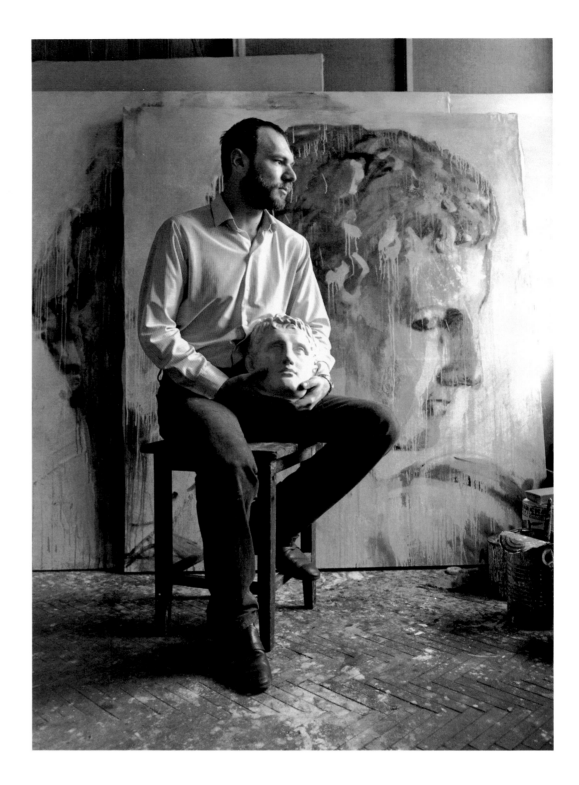

Valerii Koshliakov

"A couple of years ago I started to study classical art and implemented ideas into the series of paintings from which *Portrait of Hermes* came. I tried, though, to overcome tradition, to move further into a development of classical art. But I wanted to do it in an offhand way—perhaps in an accidental way. So I arrived at this style based on the idea that housepainters came into my studio while I was away and dripped paint on my unfinished canvas."

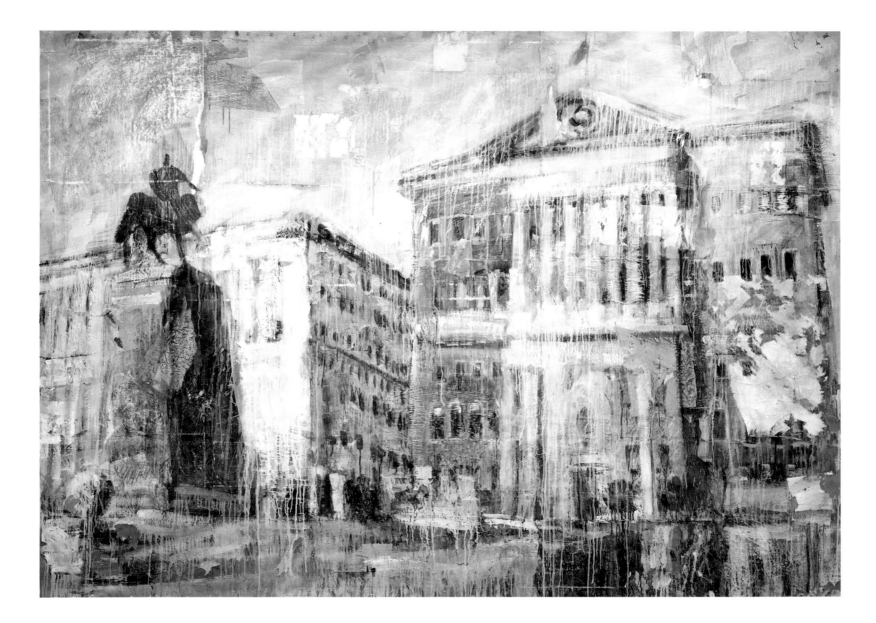

Soviet Square, 1991
Oil and tempera with applied paper on canvas, 83-1/2″ x 113-1/2″

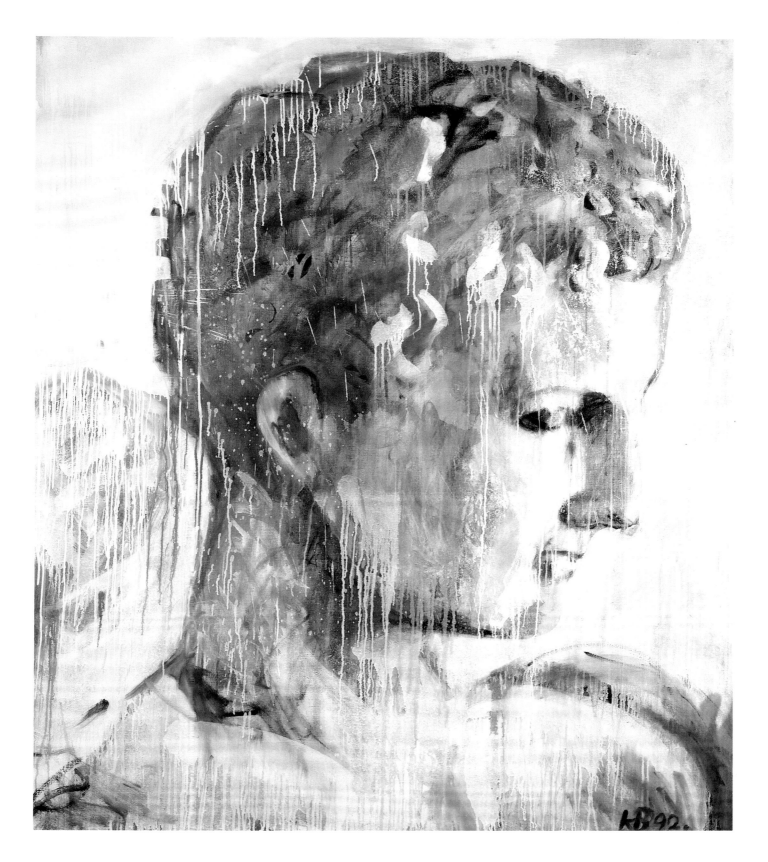

Portrait of Hermes, 1992
Oil on canvas, 67″ x 57-1/2″

The "unofficial" artists of Russia, lacking the approval of the State, supported themselves in a variety of ways other than through the sale of their fine art. At one time, Georgii Litichevskii illustrated children's books. It is therefore of no surprise that this experience overlaps his work today. Painted initially on long rolls of linen, his enlarged cartoons are often exhibited as continuous pieces, measuring as much as 35 feet in length. His subjects usually take the form of a parable utilizing characters out of modern culture.

The painting *The Artist and The Critic* may express a universal point of view, however, it seems to be even more pointedly directed toward a relationship which exists in contemporary Russian art circles. A majority of formerly underground artists refer often to the "self-important" critics and the "lack of respect and understanding" they have for their work.

The Garden of Auntie Greenfinger uses the theme of a classic fairy tale with updated characters such as Edward Scissorhands which Russians have only recently seen in movies via imported videos from the West. In this story, everything Auntie Greenfinger touches turns into trees or plants, including two young children. "Eddie" Scissorhands offers to help change the children back via electronic magic; however, Auntie Greenfinger is concerned that his magic will not work as she does not understand it.

Georgii Litichevskii

May 19, 1991. Knock knock.

I, the critic Gleb Smirnov, want to invite you to take part in a very interesting show. Please give me your cartoons.

Don't worry, this exhibition will be very important, very relevant. Are we agreed?

Let's shake on it. Because of the size of the cartoons, the critic takes them under his arm, not in a suitcase.

Artists have no sympathy for critics. But all's well that ends well. He could have kicked me down the stairs!

Our critic is on the way to his studio, which is in the same neighborhood.

Oh, these artists of mine! I am always looking for the one who can illuminate my thoughts, like a film makes clear the thoughts of the director. These cartoons though will illustrate my concept . . .

. . . of modern art quite well. To have an original idea is the job. To present these ideas to an audience in a way so that they know which side is up.

Pure thought is beautiful and perfect without any definition. 'Schon ist was ohne Begriff gefallt' *Kant.* My thought is so voluminous, so three-dimensional . . . so tactile . . . like these concrete young ladies!

By the way, the beautiful design of their ankles shouldn't go unnoticed. I must catch up with them and pay them a compliment.

Well, not bad, not bad, quite an adventure. Now it's high time to start work. So, the idea is ready. Now I must work on the phrases and style. It's different writing for cartoons.

Hello!

My God! Damned, faster, faster . . . Sweet mother!

What a misfortune! I was holding them . .

I fell in deep thought . . . And now they have disappeared . . .

You are nothing but trouble! It's in your nature, you cursed critic!

Shame on me! All is lost.

I, Gleb Smirnov, feel remorseful over losing this masterpiece. In offering him this exhibition, I wanted to wash my sin against the artist away. I want to be a good friend to the artist although I must declare that for some time, his work escaped me. Since this incident, I have preferred to know the work of old masters, as I cannot do them any harm!

The Critic and the Artist, 1992
Acrylic and ink on linen, each panel 17″ x 48″

What a spacious field for my activity.

I've done it with my own hands, young man.

Let me introduce myself. I'm Eddie Scissorhands. Excuse me, but I cannot shake hands as I have scissors instead of hands.

That's ok, shaking hands with me is not safe.

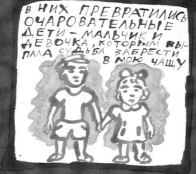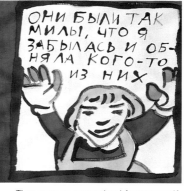

You can call me Auntie Greenfinger. All that I touch turns into trees, bushes or plants.

If you like, I'm like an anti-Midas. Everything he touched turned into gold. I'm a woman though, he's a king. I have a different filling! He turns everything into dead gold. I give everything a new life.

So, it's not that bad. The vegetation life has its own advantages; stability, faithfulness.

Yes, but it's so boring.

Take these two trees, for example.

They use to be two charming children, a boy and a girl who had the bad luck to wander into my forest.

They were so sweet that I forgot myself and hugged one of them.

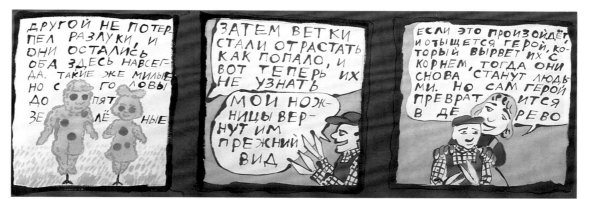

The other could not tolerate the separation, so they are staying here forever. Still nice, but green from head to toe!

Their branches started to grow and now you cannot recognize them.

My scissors will return them to their previous appearance!

If this could happen and there will be a hero who will release them by the roots, they will become human again. But the hero himself will turn into a tree.

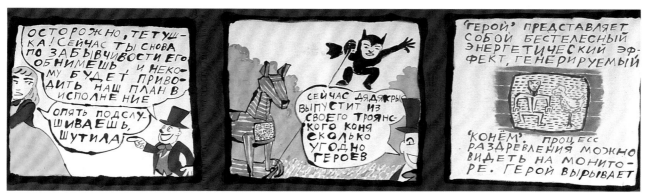

Be careful Auntie, you may forget yourself again, give him a hug, and then there will be no one left to realize our plans.

Joker, you are eavesdropping again!

Now, the "Uncle of Rats" will release an indefinite number of heroes from his Trojan Horse.

The hero is actually an energetic effect without a body which is generated by the "Horse." The process of strip-trees-ness is on the monitor. The hero pulls . . .

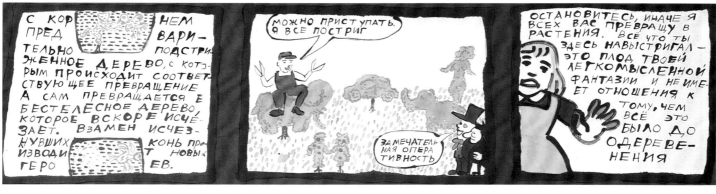
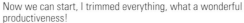

. . . by the roots, the preplanted and trimmed tree which now will have the following metamorphosis. The hero himself will turn into a tree, without a body which will soon disappear. So, instead of the disappeared heroes, the horse will produce the new ones.

Now we can start, I trimmed everything, what a wonderful productiveness!

Stop, all of you, or I will turn you into plants! All of your trimmed creations are the fruit of your lightheaded fantasy. It has nothing to do with what these creatures used to be before turning into trees.

I don't even remember myself which of the trees is a boy, and which is a girl. We cannot allow them in their new life to be switched.

I usually reminisce about what happened in my sleep. I'd better lie down. Maybe I'll remember which of the trees is a girl and which is a boy. Meanwhile, you should take your water hoses and water all the trees.

ZZZ . . . Start your horses, you Uncle of Rats!

The Garden of Auntie Greenfinger, 1993
Acrylic and ink on linen, each panel approximately 17″ x 48″

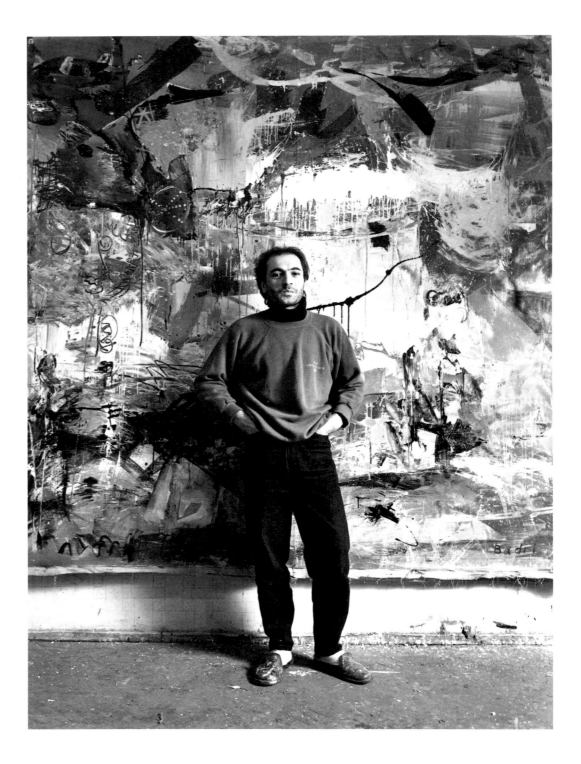

Bɑdri Lomsianidze

"I have painted since I was a child. My earliest influence was the Impressionists. Today, I like a variety of artists from Antoni Tapies to Bruce Nauman. As for my most recent series of abstract paintings, I interpret them as sketches. I don't want to lose the vitality of the original sketch, so I've enlarged my sketches into paintings. The device of the border is like a frame. By adding the frame, I'm indicating that I have completed the piece. It also functions as a graphic element, a part of the whole painting."

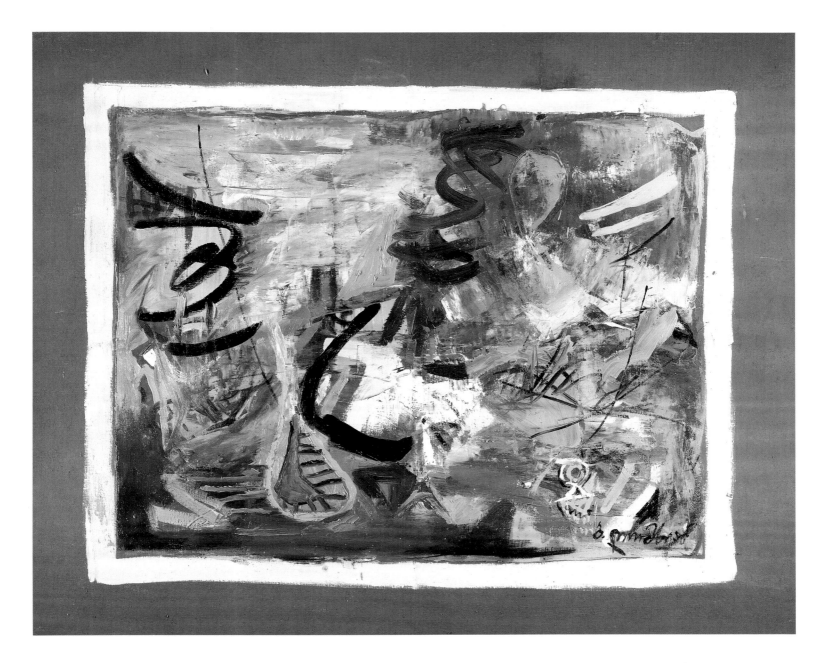

Untitled, 1992
Oil on canvas, 54-3/4″ x 66-1/2″

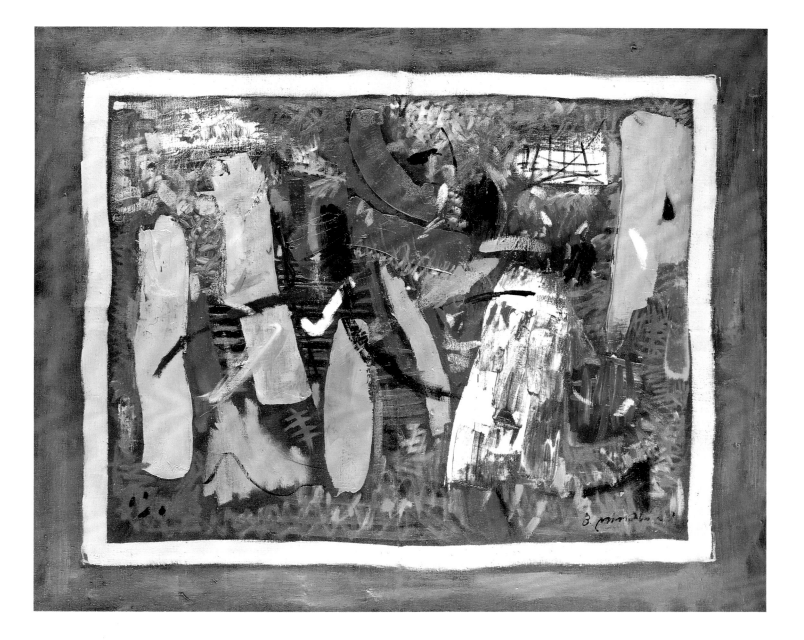

Untitled, 1992
Oil on canvas, 54-3/4″ x 66-1/2″

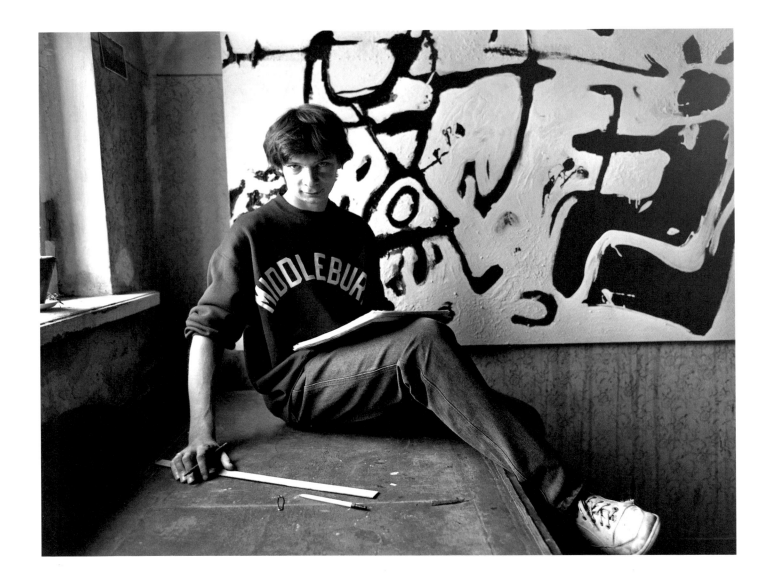

Bogdan Mamonov

"*Portrait of an Unknown Man* is the title of a second exhibition in which I dealt with criminology methods to try and define a concept. All of the paintings in the exhibition were also titled *Portrait of an Unknown Man*. The first exhibition was titled *In Search of a Vanished Masterpiece*. I have a theory that culture and civilization are two different things. We're so involved with our language that it separates us from reality. It determines our attitude toward reality, it defines our culture. So to penetrate this cultural layer between us and reality, we must split it in half. Classical Russian portraiture is one of the clearest symbols of this culture. In these paintings, I was looking for a method of investigation that could split that cultural layer. I use the face of Mao on all the portraits with different bodies, because it is a stereotypical Chinese face. Like in a criminal record book, where you substitute faces over different bodies. It's a starting point in the investigation."

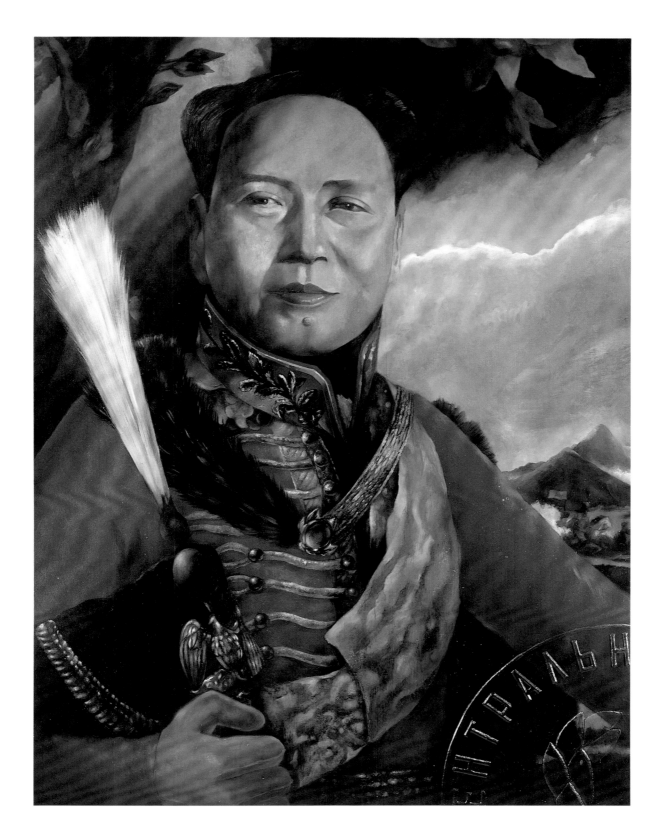

Portrait of an Unknown Man, 1992
Oil on canvas, 78″ x 56″

Andrei Medvedev

"I have always used dolls as subjects. After all, they are like people, only they don't move, and they sit still for you! I saw a mummy once and it made a very strong impression on me. It had been human and yet the face had become hard like a doll's. I also like death masks, because you can hold one and study the features and know they came from a real person. What is in the mask is not real, but it does give the real impression of a personality that existed."

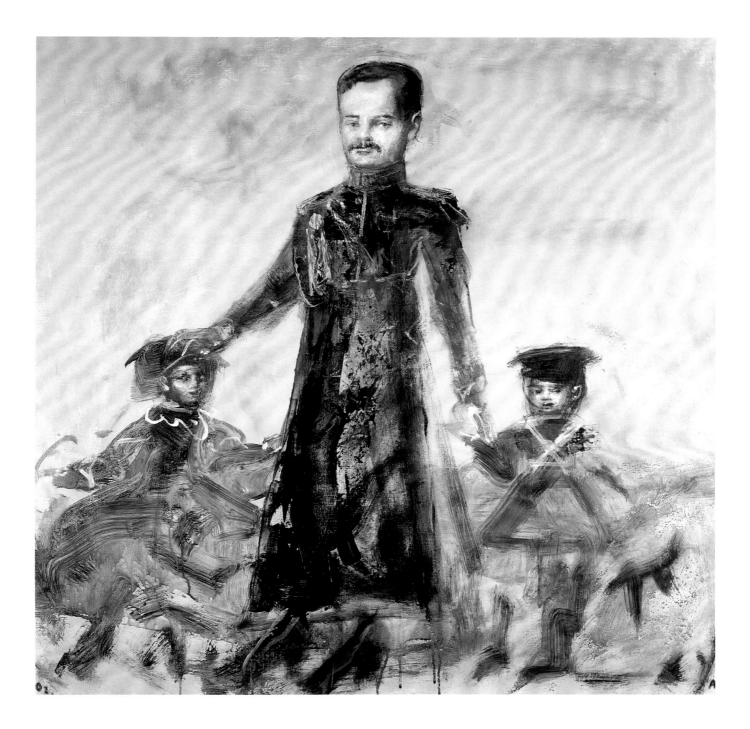

The White Officer, 1990
Oil on canvas, 39″ x 39″

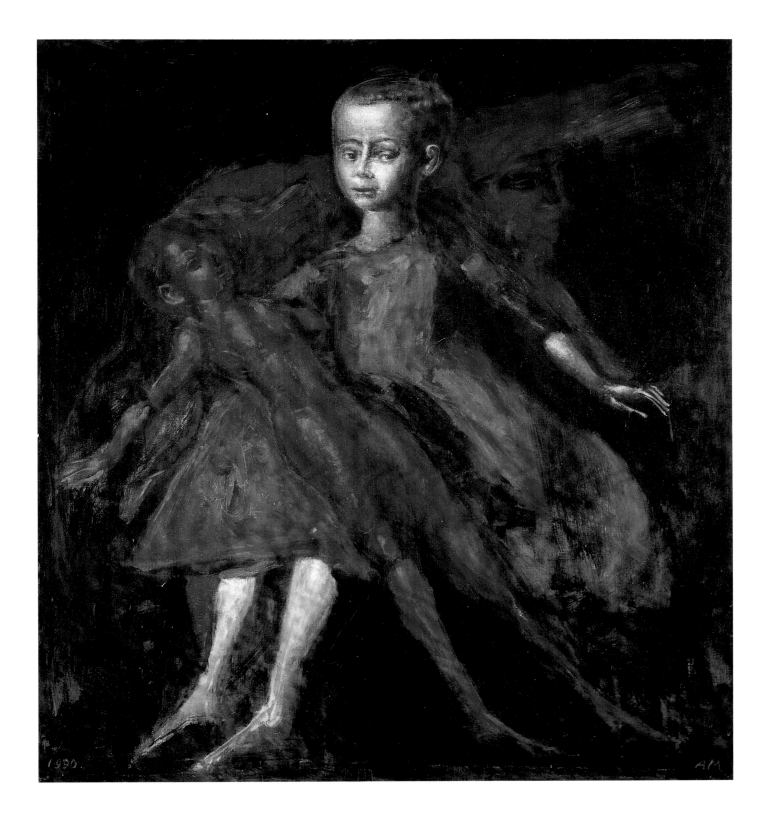

Lament of the Dolls, 1990
Oil on canvas, 46-1/2″ x 42-1/2″

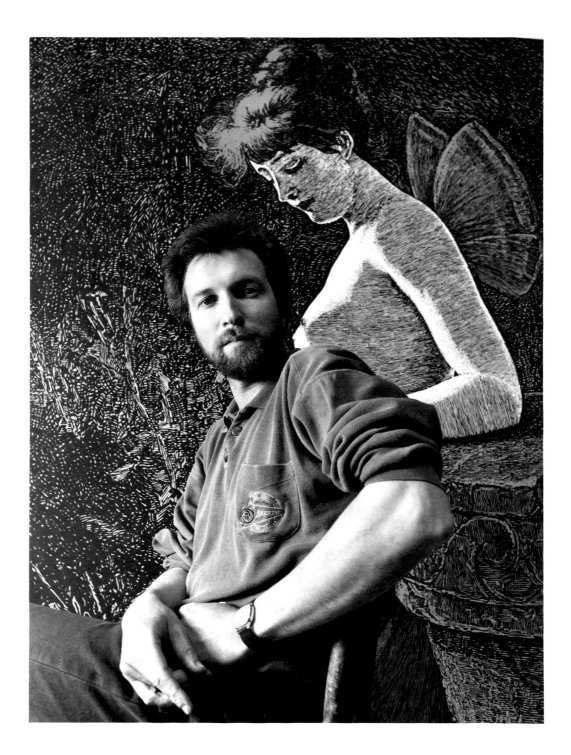

Sergei Mironenko

"Avant-garde has exhausted itself and has turned completely into pure style. Denying the idea of any new movements, considering them banal, I am trying to minimize my choice of sources and references. Many mistakenly consider the epoch of world decadence as a decline, in spite of the achievements in art. For example, gravure is one of the most conservative of techniques, but it became an art form. I refuse to use any mechanical means to transfer an image to canvas, even if it eventually looks like a gravure print. I insist on the importance of handwork which reflects the move from aesthetic to ethical."

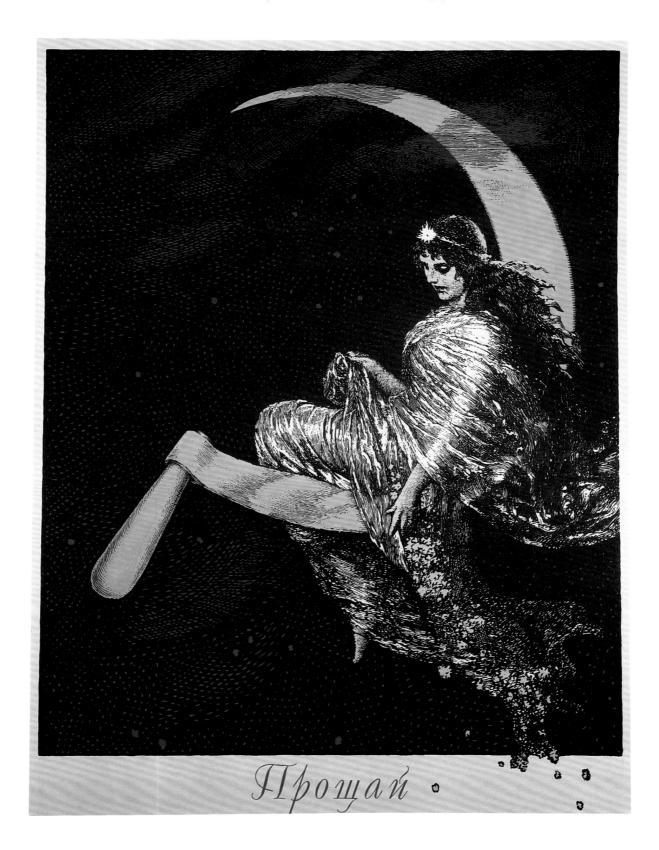

Прощай

Goodbye, 1992
Acrylic on canvas, 76" x 56-1/2"

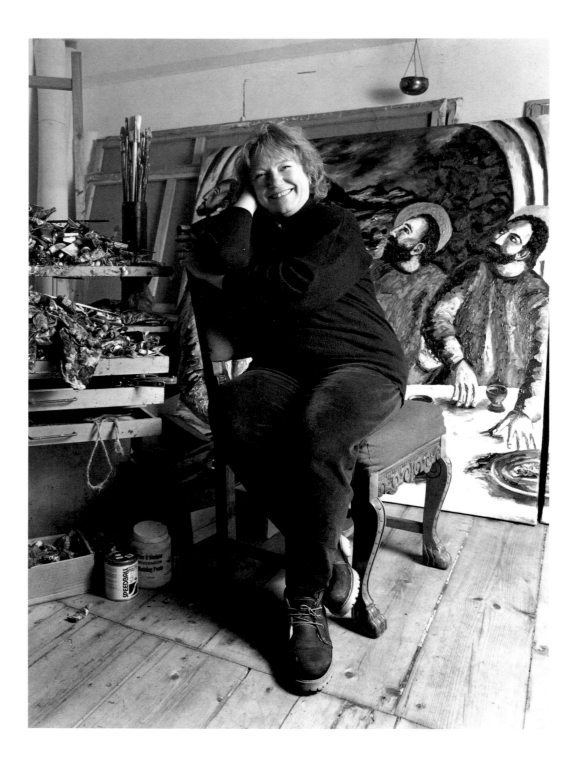

Natalia Nesterova

"I was in Canada for an exhibition of my work and saw the Cirque du Soleil. I went to see it again in New York and was so impressed by the performers that I produced a series of paintings of them. I enjoyed the concept of this particular circus; their music and their acts were so different from any I had seen. The color of the costume in *Tightrope* is quite accurate, but the umbrella with the Yiddish word for *balance* was my own strange idea. There's no direct connection and no particular significance."

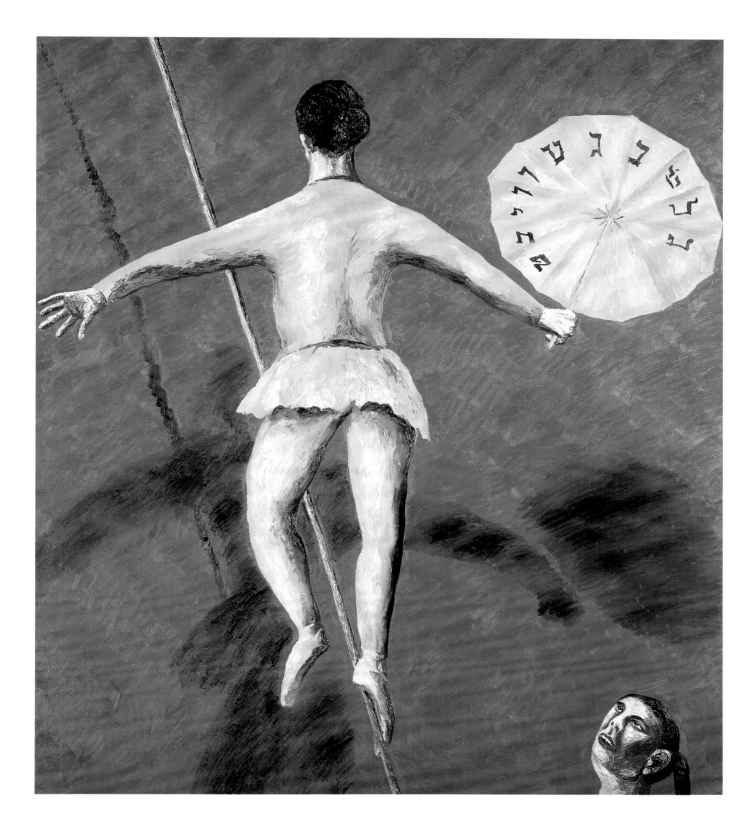

Tightrope, 1992
Oil on canvas, 62″ x 54″

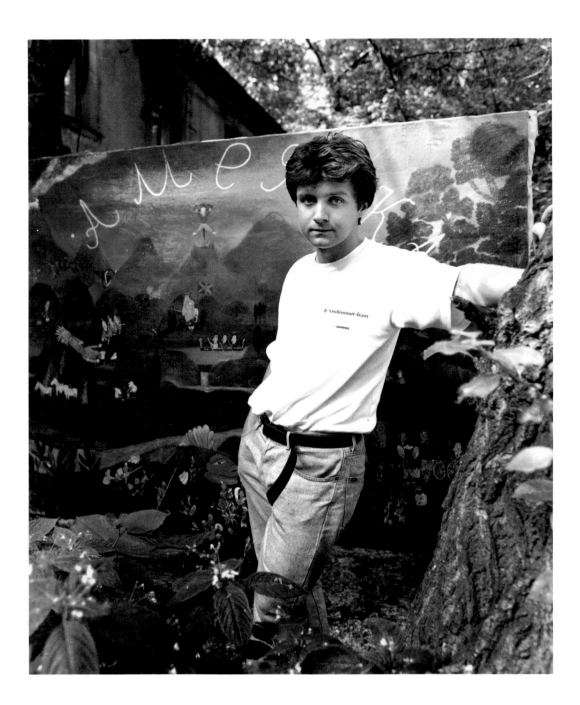

Igo*r* Nezh*i*voy

As in Henri Rousseau's naive paintings where subjects inhabit uncivilized landscapes, we see in Igor Nezhivoy's canvases a similar tableau. The cast of characters in *America* (spelled with the Russian letter for C) is enormous. The artist has stated it represents his impression of the exploration of the American frontier, yet the figures in this landscape oddly resemble the Lilliputians from *Gulliver's Travels*. Such artistic license is common in Nezhivoy's work.

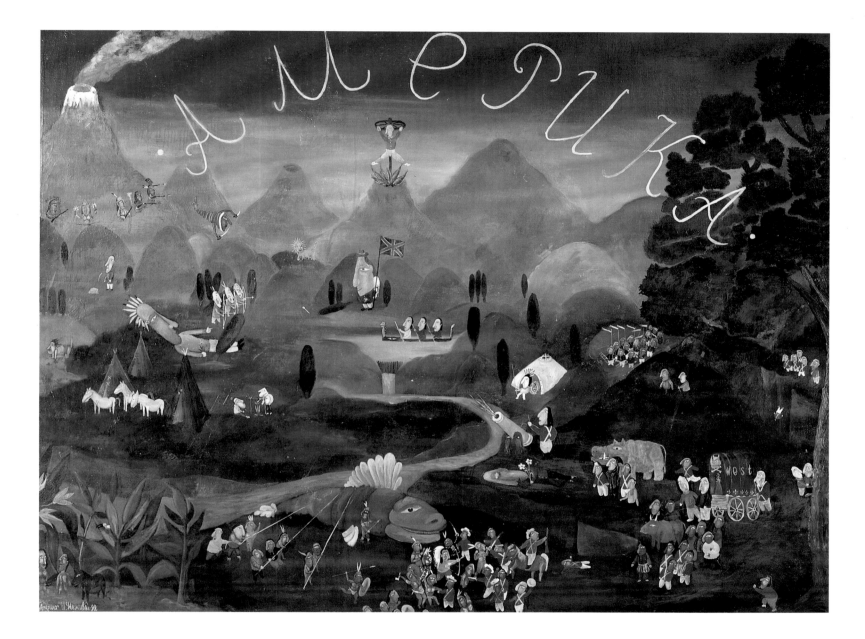

America, 1992
Oil on canvas, 60″ x 78″

Timur Novikov

"Human vision has to do with objects of various magnitudes situated in space:

a table – a matchbox
a mountain – a tree
outer space – a star
the sky – the sun
a newspaper – a letter
a floor – a chair
a road – a car

Spaces of differing magnitudes are encountered much less often. It was this simple observation which led me to use fine detail on a large surface. I consider this spatial model to be more natural."

Symbols of Water, Earth and Air, 1991
Oil stencil on paper (unique), each image 24″ x 17″

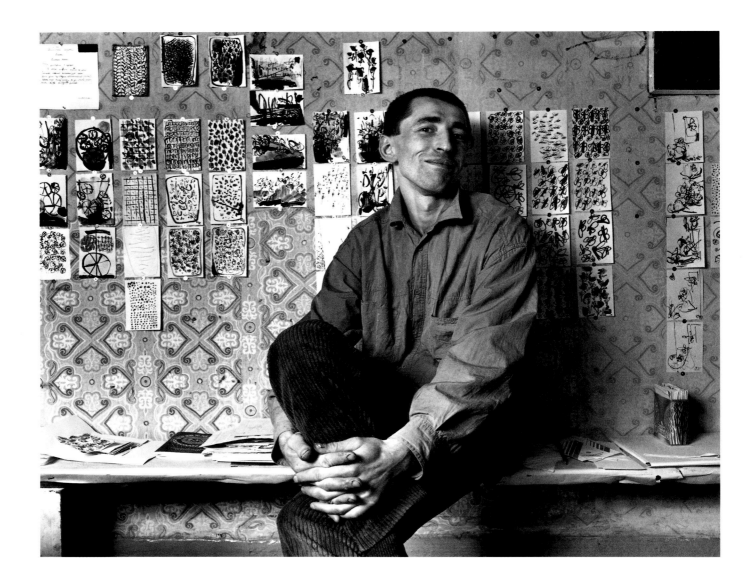

Ivan Olasuk

"When I begin a painting, I have no idea what it will look like. I come to the white canvas and empty myself. I begin to use symbols. Circles in a painting are symbolic. They may symbolize movement. It may be the movement of a wheel. The wheel may symbolize progress. The circle may resemble a butterfly which symbolizes nature's role in progress. Intuition is important in the process. I may live with a painting over a period of time and one day intuitively decide to add something. For example, the blue lines on the surface of a particular painting may have been added long after I thought the piece was finished."

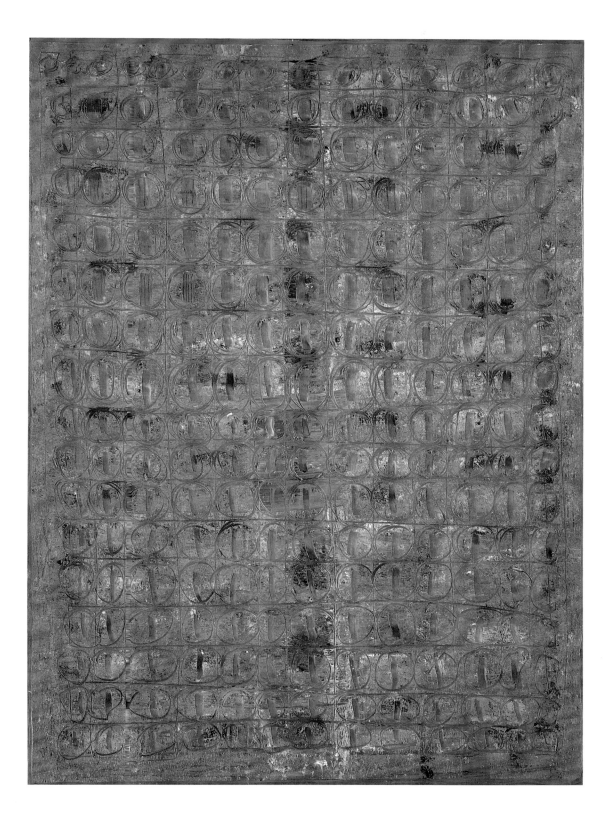

Untitled, 1992
Oil on canvas, 45-1/2" x 33"

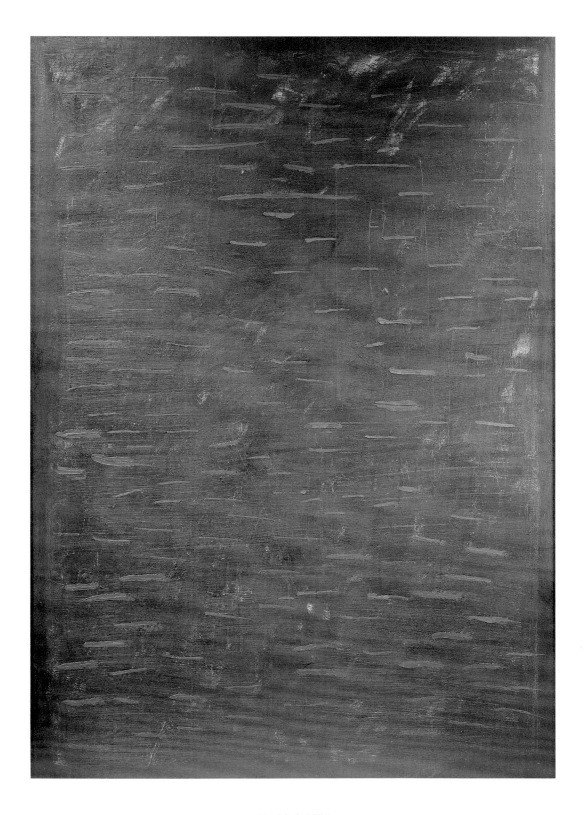

Untitled, 1992
Oil on canvas, 79-1/2″ x 55″

Aleksandr Roitburd

Internationally, Neo-Expressionist painting became popular in the mid to late 1980s and was representative of a shift from modernism to postmodernism. Artists such as Francesco Clemente from Italy, Anselm Kiefer from Germany, and Julian Schnabel from Spain had a tremendous influence on artists worldwide, including a new generation of Russian artists. Aleksandr Roitburd, from Odessa in the Ukraine, adopted the style and chose primarily biblical subjects to interpret. As a purely emotional device, the surface of the canvas in his triptych *Contemporary and Classic Art (Portrait of the Artist as Caravaggio)* is so textural that it becomes charged with movement. The repetition of imagery is clearly a postmodernist touch. The monumental size of the painting is also characteristic of Neo-Expressionism.

Contemporary and Classic Art (Portrait of the Artist as Caravaggio), 1991
Oil on canvas triptych, each canvas 77″ x 174″ overall

Arsen Savadov & Georgii Senchenko

Since their emergence on the contemporary Moscow art scene in the late 1980s, Kiev painters Arsen Savadov and Georgii Senchenko have left both conservative and liberal critics alike wondering how to describe their art. The terms *postmodern* and *trans-avant-garde* have been applied, as have *simulational* and *conceptual*. A majority of their large, installational works, have become three-dimensional, involving materials such as the ropes tied in nautical knots in *Paradise Lost* which anchor the unframed canvas. The artists have stated, "We are trying to manipulate the structure of our pictures, making it open to all consciousness. We have no aim in our movement . . . Aim is nothing, movement is everything."

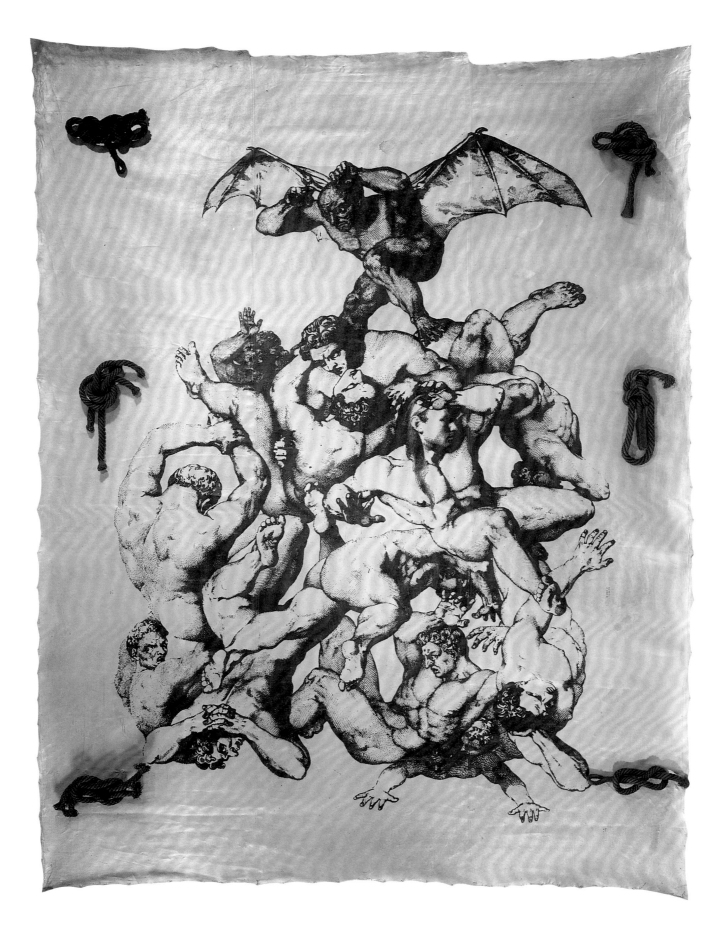

Paradise Lost, 1991
Silkscreen on painted canvas with 6 attached ropes, 145″ x 110″ (unstretched)

Swan Lake, 1991
Oil on Red Army canvas tent with affixed lithographer's plate, 65″ x 66″

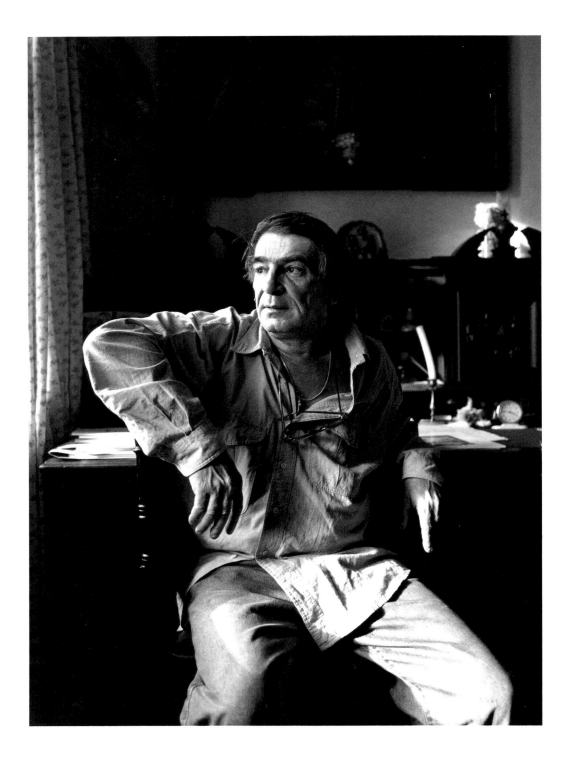

Eduard Shteinberg

Part of a generation of artists who grew up studying the first Russian avant-garde, Eduard Shteinberg has taken an entire career to come under their influence. Having no formal training, he studied painting under his father, who had gone to the VKhuTeMas, a progressive art school of the 1920s. In the late 1960s, Eduard's work began to resemble the sparse, geometric compositions of Malevich. Moving into the 1970s, his paintings contained recognizable elements of the landscape, and into the early 1980s they often dealt with language and figurative subject matter. Over the last ten years, he has concentrated on geometric and abstract shapes representing metaphysical and spiritual issues that have become important to him later in life.

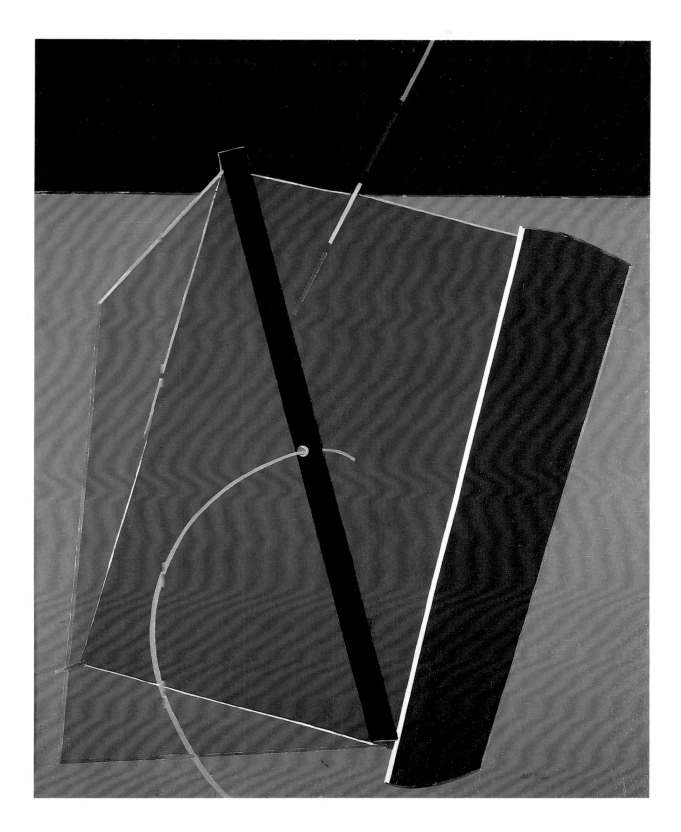

Composition, December, 1988
Oil on canvas, 39-1/4″ x 31-1/4″

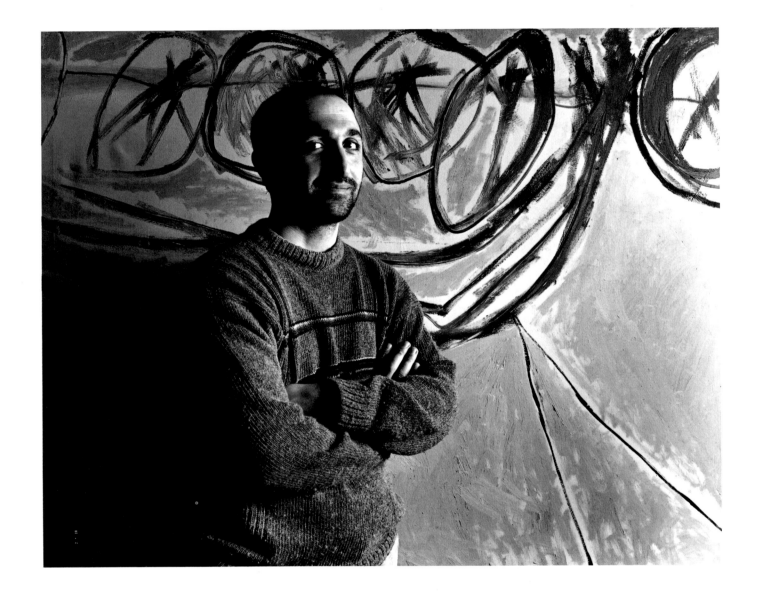

Roland Shalamberidze

"I believe it is important for a painter to be educated in arts other than his own. I first studied poetry and then music, and I trained myself to write as well as compose. When I began to paint, I was more of a surrealist. I think it is important to educate oneself in order to make the journey from reality to that of abstract life. When I now look at figurative paintings, I see movement and I try and put that movement into my abstract works."

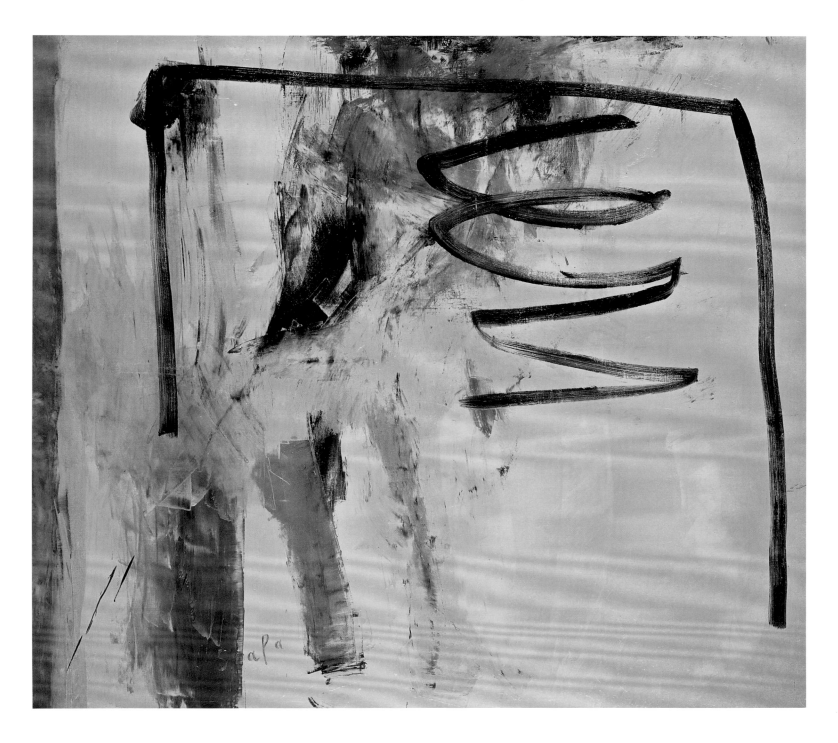

Untitled, 1992
Oil on canvas, 56″ x 62-1/2″

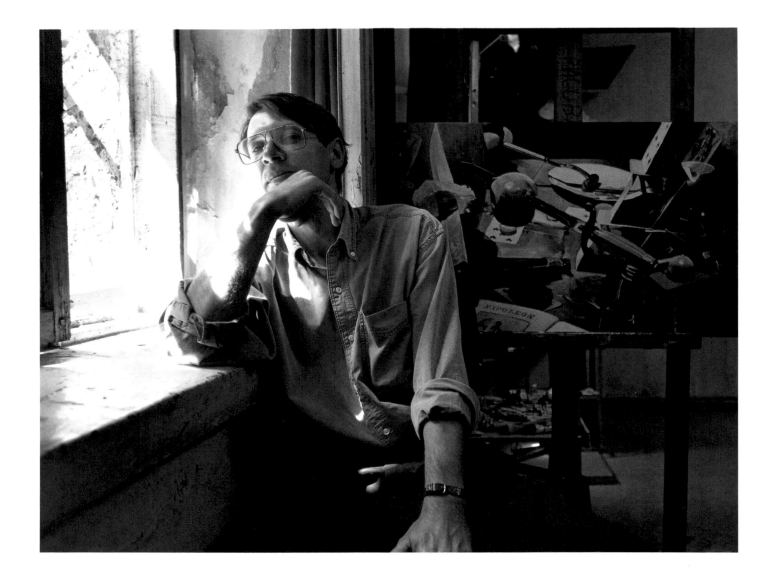

Sergei Sherstiuk

"The painting *The Letter* is from a series I did based on a children's book published in 1937 and titled *Scientific Experiment*. It consists of chapters like "How to Write a Letter on Your Head While Looking in a Mirror," which says you have to take a pencil and a piece of paper and sit across from a mirror so you can see what you are writing. I read the book when I was a child and I realize now the insanity of the environment then was really what the book was about; the craziness of life around us. It was absurd. The bottle in the upper corner of the painting is actually my protest of this book. Because really, if you want to write a letter and send the letter, it's probably easier to put it in a bottle and throw the bottle in the ocean! That's the absurdity, so I approach this absurdity with another absurdity."

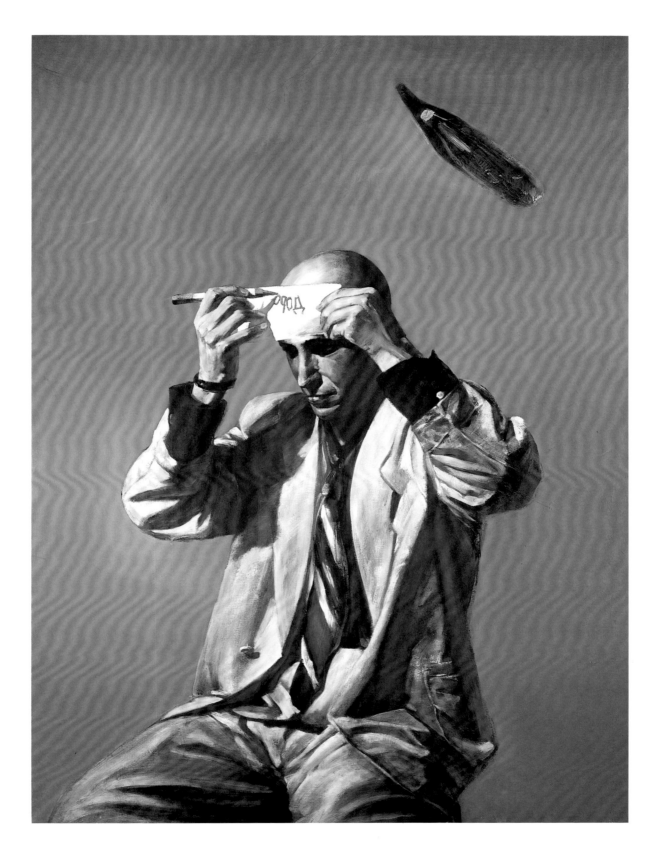

The Letter, 1989
Oil on canvas, 77-3/4″ x 57-1/2″

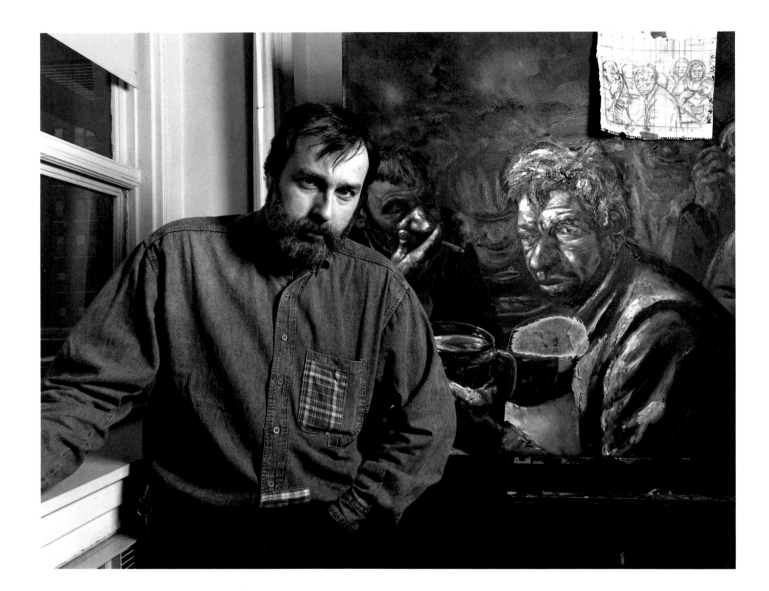

Vasilii Shulzhenko

"A lot of my paintings come from my dreams. I keep a note pad by my bed and when I wake up, I write them down. The painting *The Philosopher* has no particular meaning to me. I saw him in my dream and I painted him. I think most of my paintings deal with the conditions of everyday life. So many people bring their own interpretations to my work, and that is fine. It's not necessarily what I see, but it's fine."

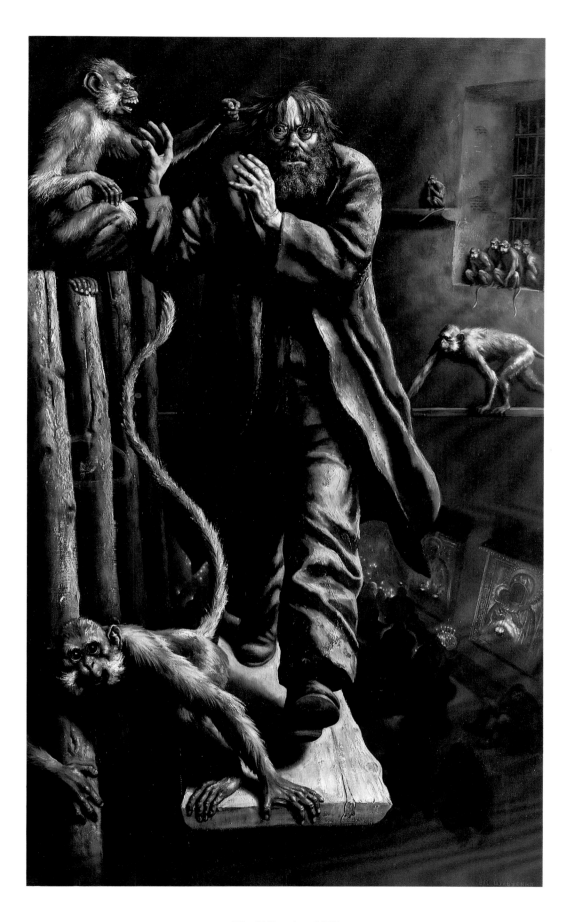

The Philosopher, 1992
Oil on canvas, 77-1/2" x 46"

Aleksandr Sigutin

"Since my childhood, I had a dream to be a teacher. I was in the navy, and then I went back to school, graduated, and became a gradeschool instructor. But I had to have my own daughter and become a painter before I realized the importance of children's drawings. I now use elements of children's art to find solutions to artistic problems. There is pure geometry in the way they draw and I apply that to my art."

Untitled, 1993 (from the series *Samples of Children's Works*)
Oil on canvas, each canvas 20″ x 24″

Untitled, 1993 (from the series *Samples of Children's Works*)
Oil on canvas, 47″ x 58″

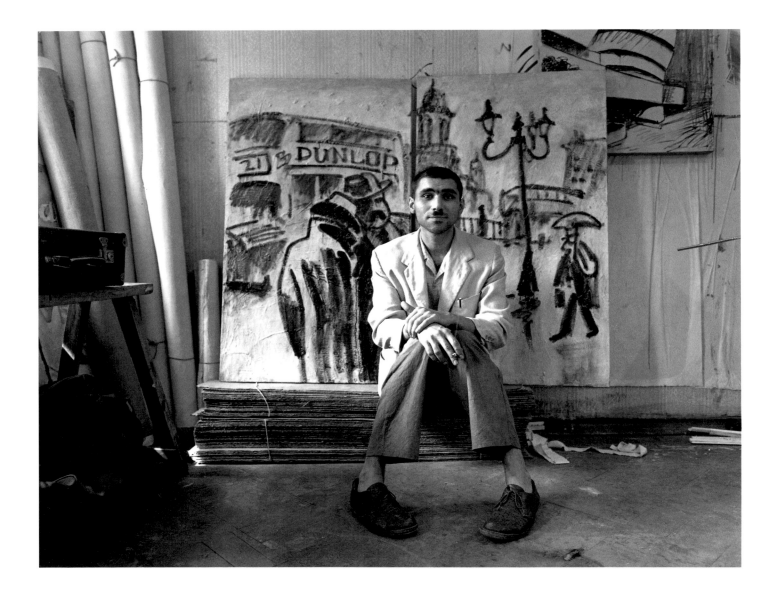

Avdei Ter-Oganian

"I grew up in the provinces in Southern Russia and as a child, I studied modern art in books which were meant to discourage us; books with titles like *Why I Am Not A Modernist*, *The Truth About Abstract Art*, and *In the Jungle of Figurativism*. I still wanted to be a modernist, however, and so I came to Moscow a few years ago, only to find that modernism was dead. So I began to create my own museum as a tribute to my heroes like Picasso, Matisse, and Cézanne. *An Englishman In Moscow* was one of my favorites from a 1914 painting by Malevich."

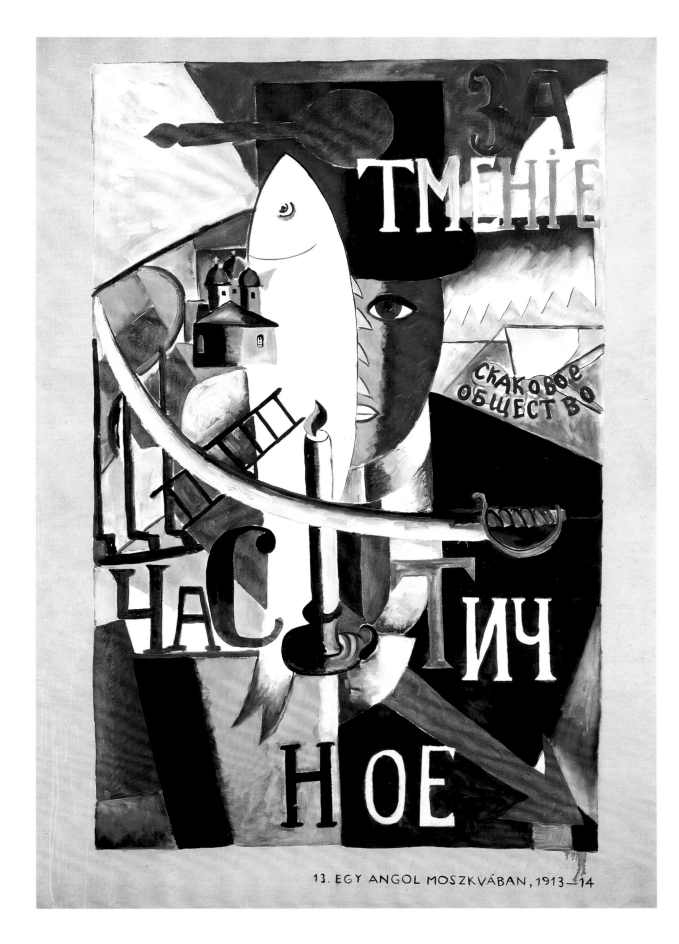

A Page from a Hungarian Album (After Malevich's An Englishman in Moscow, 1914), 1992
Oil on canvas, 77-1/2″ x 54″

Avdei Ter-Oganian's characterization of himself as an artist from the provinces who comes to the big city in search of modernist art is a cleaver story by a true postmodernist. *A Page from a Hungarian Album* came from the series *Pictures for a Museum* and, while seemingly accurate to the eye, contains subtle differences when compared to the original work by Malevich. The painting *Never Say Never* is from his *James Bond* series and, in true appropriationist form, borrows an image from popular media, in this case a black-and-white publicity still for a James Bond movie of the 1970s. He has reinterpreted it in a loose figurative style, even dividing the work into a diptych. The surface of this piece, painted on board, is heavily textured and rough, contradicting the photographic clarity of the original black-and-white print.

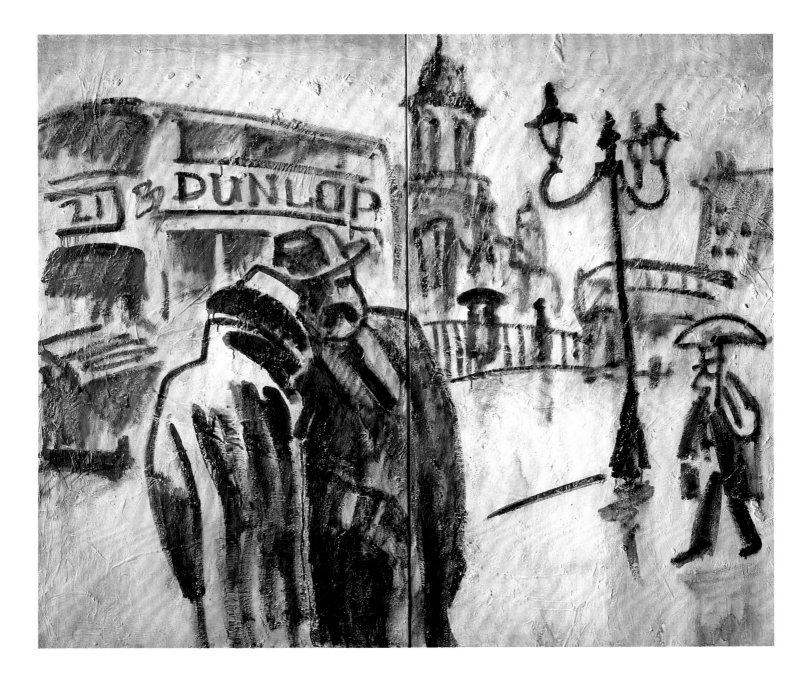

Never Say Never, 1992 (from the *James Bond* series)
Oil and gesso on board diptych, 51″ x 59″ overall

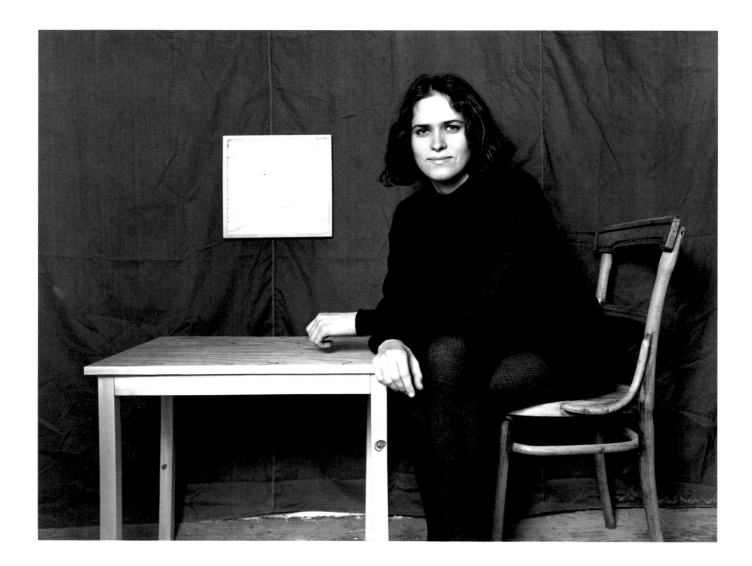

Inessa Topolskii

"The sixteen small canvases—fragments, when combined in a specific way—represent a painterly replication of a famous Rembrandt work. The dividing of the image refers directly to a children's puzzle game. In combination with the intensity of Rembrandt's scene, it produces a dissonant effect, becoming a subject with dramatic influence and, at the same time, an infantile joke. The medical 'transplantation' becomes a real transplantation of the painting's body (the canvas). Stratification of the game's idea and the visual effect (idea and method) of the thoroughness of Rembrandt's technique, combined with the naiveness of the pseudocynical manipulation of a famous work of art, serves as a quasi-metaphor for the entropy. If one, playing with the odd fragments, happens to be smart enough to put them back in order, the only thing left for him is Hamlet's torments!"

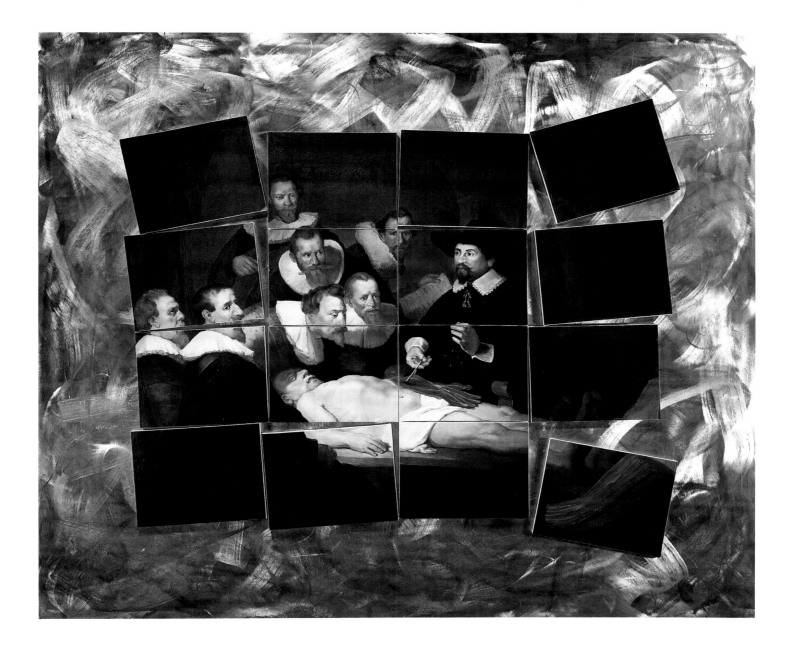

Dr. Thulp's Anatomy Lesson, 1991
Oil on canvas, each canvas 9″ x 12″
attached magnetically to 55″ x 79-1/2″ polished sheet metal base

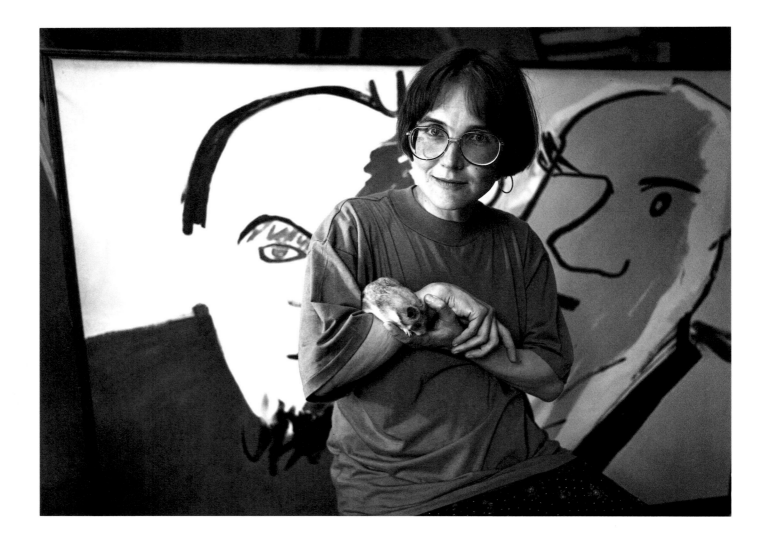

Natasha Turnova

"It used to be in our country that all political leaders could only be represented in a Social Realist style of painting. An artist could be prosecuted for distorting the standard in any way or even for interpreting a smile. Of course, in the last couple of years, it's become possible to paint any way you like. My paintings are a response to the old standards being broken. The traditional poses were stiff and the attitude quite serious. In the piece *Lenin and Tolstoy, What to Do?* I combine the old view of these famous Russian figures with my interpretive one. The colors are sort of reactionary too."

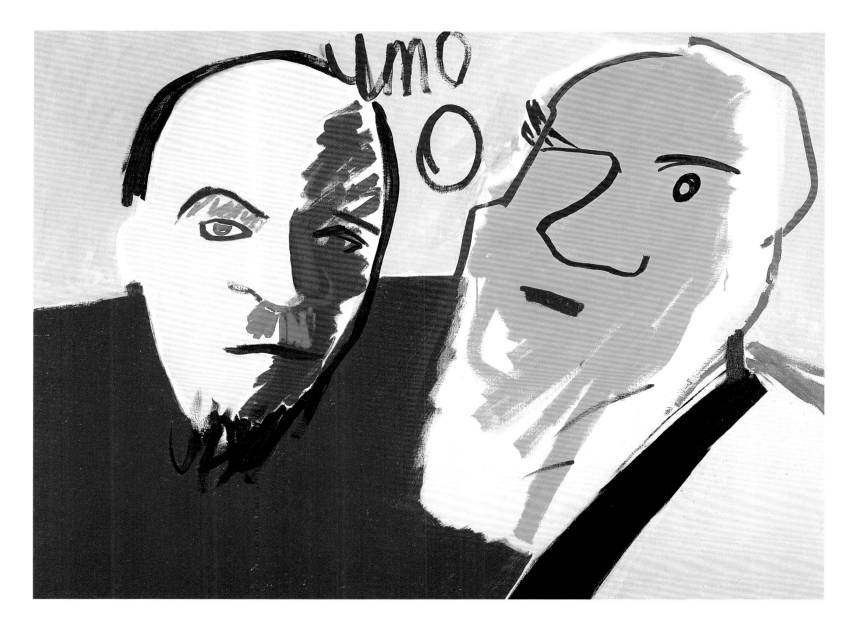

Lenin and Tolstoy, What to Do?, 1989
Oil on canvas, 54″ x 73-1/2″

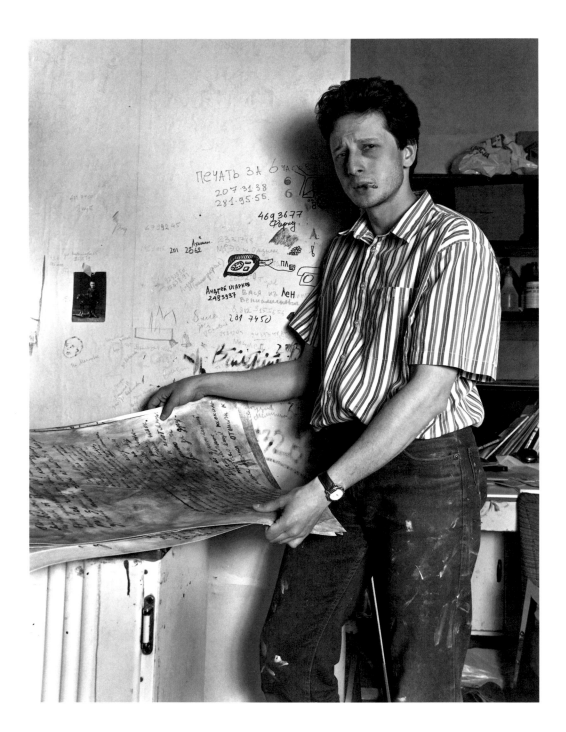

Andrei Yakhnin

"The series of paintings, all under the title *Short Stories*, comprise a novel which is not to be published, but will be introduced in museums and galleries. It is therefore communicated only within the channels of art, through exhibitions and catalogs. I am planning 70 chapters of this novel. As the author, I go to 70 apartments in a building and listen to the stories of the occupants in the apartments. In this particular chapter, I write about a man who is an explorer who walked to the North Pole. He froze his arms off and had to train himself to write with his feet. . . . In other chapters, I meet a pilot and one of Hitler's ex-lovers."

Short Stories, 1993
Oil on canvas, 2 pieces
Left side 54-1/2″ x 76″, right side 54-1/2″ x 46-1/2″

Artists' Chronologies

So much has happened to this group of artists over the past ten years, from their involvement in international exhibitions (primarily European) to their associations with a number of recently opened galleries and alternative spaces in Moscow. Their activity has been truly phenomenal. We wish to thank the numerous gallery and museum individuals who have assisted us with the compilation of this material. Most importantly, a debt of gratitude goes to Tania and Natasha Kolodzei of Moscow for their communication with the artists themselves regarding the updating of this information.

Gia Abramishvilii

1966	Born, Moscow
1986	Becomes member of Champions of the World group
1986–89	Group exhibitions with Champions of the World, Moscow
1988	"Labyrinth," Palace of Youth, Moscow
1989	Becomes member of the Graphics Union, Moscow
	"Mosca: Terza Roma," Sala I Gallery, Rome
1990	Venice Biennale, Russian Pavilion, Venice
	"The Green Show," Exit Art, New York
	"The Quest for Self-Expression: Painting in Moscow and Leningrad, 1965–1990," Columbus Museum of Art, Columbus (travels extensively throughout the U.S. in 1991)
	"In the USSR and Beyond," Stedelijk Museum, Amsterdam
1991	"World Champions," Pori Art Museum, Finland; Galleria Sprovieri, Rome; Seibo Art Forum, Tokyo
1992	"Mosca a Mosca," Villa Campoletto, Naples, Galleria Sprovieri, Rome
1993	"Avestmenti," Galleria Sprovieri
1994	"Artist Instead of Art: Jump Into the Emptiness," Central Artists House, Moscow

Semeon Agroskin

1961	Born, Moscow
1980	Graduates, Moscow Institute of Architecture
	Becomes member of USSR Artists Union
1989	"Labyrinth," Warsaw; Hamburg
	"Eidos," Palace of Youth, Moscow
	Group exhibition, Kastropblausel Town Hall, Kastropblausel, USSR
	"Freies Rheinland," Zollhofhall, Dusseldorf
1990	"Artistes à la Bastille," Paris
1991	One-man exhibition, Guelman Gallery, Moscow
1992	One-man exhibition, Guelman Gallery, Moscow

Yurii Albert

1959	Born, Moscow
1977–80	Studies, Pedagogical Institute, Moscow
1980s	Aptart exhibitions, Moscow
1983	"Aptart en Plein Air," Moscow
1986	17th Annual Youth Festival, Kuznetski Most, Moscow
1987	First exhibition of the Avant-Gardists' Club, Moscow
1987	"Visual Artistic Culture," Hermitage Association, Moscow
1988	"Labyrinth," Palace of Youth, Moscow; Warsaw; Amsterdam; Hamburg; Paris
1988	"The New Russians," Palace of Culture and Science, Warsaw
1989–90	"10+10," Modern Art Museum of Fort Worth (travels extensively throughout U.S. and Russia)
1990	One-man exhibition, Krings-Ernst Gallery, Cologne
1991	"Artistos Russos Contemporaneos," Auditorio de Galicia, Santiago
	"MANI," Museum 40 Moskauer Kunstler, Frankfurt
	"Gulliver's Travels," Galerie Sophia Ungers, Cologne
	"Perspectives of Conceptualism," Clocktower Gallery, New York; Honolulu

Nikita Alexeev

	"Ost Kunst-West Kunst," Ludwig Forum, Aachen
1992	"Mosca a Mosca," Villa Campolieto, Ereolano; Galleria Comunale d'Arte Moderna, Bologna
	"CoeArt," Galleria Bianca Pilat, Milano
	"Third International Istanbul Biennale," Isantbul
1993	"Rinaco Collection of Contemporary Art," Central Artists' Hall
	"Moscow: Espace d' Exposition," Caisse des Depots, Paris
1994	"Fluchtpunkt Moskau," Ludwig Forum, Aachen

1953	Born, Moscow
1972	Graduates, Moscow Art College
1976	Graduates, Moscow Polygraphic Institute
1977	Venice Biennale, Russian Pavilion, Venice
1982–84	Numerous Aptart exhibitions
1988–90	"Isskunstvo, Parts 1, 2, & 3," Berlin; Moscow; Stockholm
1990	"Love and Death of Nikita Alexeev," one-man exhibition, Galerie Roesinger, Cologne
1991	"Kunst Europa," Kunstverein
	"The Positions in Contemporary Russian Art," one-man exhibition, Galerie Nalepa, Berlin
1992	"The Haystack," one-man exhibition, First Gallery, Moscow
	"The Cruciform Songs," one-man exhibition, L Gallery, Moscow
	"Palais de l'Arle-Balais," one-man exhibition, La Base, Paris
1993	"Provisory Address for Russian Art," Muse de la Poste, Paris
	"Mosca a Mosca," Villa Campoletto, Naples
	Frankfurt International Art Fair, L Gallery, Frankfurt
	"Gravity and Tenderness," one-man exhibition, L Gallery, Moscow
1994	Chicago International Art Fair, XL Gallery, Chicago

"Two Moons," one-man exhibition,
XL Gallery, Moscow
"Nikita Alexeev: Paintings, Drawings,
Sculpture," Yakut Gallery, Moscow

Farid Bogdalov

1963 Born, Lukhovitsy, USSR (currently
 resides in Moscow)
1980–84 Studies, Moscow Art School, Moscow
1984–86 Studies, Surikov Art Institute, Moscow
 (graduates, 1986)
1986 Establishes residence in Furmanny
 Lane, Moscow
1988 Becomes member of Champions of the
 World group, Moscow
1989 Becomes member of the Graphics
 Union, Moscow
 "Mosca: Terza Roma," Sala I Gallery,
 Rome
 "Furmanny Lane 1," Bologna
1990 Co-founds Boli group with Georgii
 Litichevskii
 "Furmanny Lane 2," Switzerland
 "White Action," with Boli group, Moscow
 "Mothers of Pinocchio," with Boli group,
 Moscow
 "Russian Ravioli," with Boli group,
 Moscow
 "Moscow Zoo Exhibition," with Boli
 group, Moscow
 "Traditions of Russian Painting,"
 Reconstruction of Moscow Museum,
 Moscow
 "The Quest for Self-Expression: Painting
 in Moscow and Leningrad, 1965–1990,"
 Columbus Museum of Art, Columbus
 (travels extensively throughout the
 U.S. in 1991)
1991 "Exercises in Aesthetics," with Boli
 group, Kuskovo Museum, Moscow
 "Milano-Poesia," with Boli group, Milan
 "New Neon Cube," with Boli group,
 Kuskovo Museum, Moscow
 "Chistaprudnii Boulevard," Gallery XXI,
 Madrid
 "15 Positions of Time (Art Through
 Boundaries)," Linz Museum of Art,
 Austria
 "Crossing Boundaries," with Boli group,
 San Francisco
 "Novocento," Central Artists House,
 Moscow
1992 Third International Istanbul Biennale,
 exhibition of "Trojan Horse," with Boli
 group, Istanbul
 "Cubopressure," with Boli group,
 Moscow; San Francisco; Milan; Pistoia

1993 ART MIF, International Art Fair,
 Moscow
 "Monuments," Central Artists House,
 Moscow
 "Through the Boundaries," Russian
 Cultural Foundation, Moscow
1994 "Works on Paper: Selections from the
 Kolodzei Collection," City Arts Center,
 Oklahoma City

Sergei Bugaev (Afrika)

1966 Born, Novorossisk on the Black Sea
 (currently resides in St. Petersburg)
1980 Moves to Leningrad to study with
 underground artists and poets
1982 First one-man exhibition in apartment
 of Timur Novikov, Leningrad
1983 Organizes ASSA group, Leningrad, an
 underground organization of artists,
 musicians, and filmmakers
1984 Becomes member of rock group
 Popular Mechanics, tours USSR and
 Europe
 Society of Experimental Art Exhibition,
 Palace of Youth, Kirov Palace of
 Culture, Leningrad
1986 "The New Artists," 17th Annual Youth
 Festival, Central Artists House, Moscow
1987 "Bez Oreoloa," Gdansk Kantor Sztuki,
 Gdansk, Poland
 Forms the Friends of Mayakovsky Club
 with Timur Novikov
1988 "7 Independent Artists from Leningrad,"
 Young Unknowns Gallery, London
 "The Leningrad Show: 21 Artists from
 the Fellowship of Experimental Art,"
 Memorial Union Art Gallery, University
 of California, Davis
 "The New Artists," The Culture House,
 Aarhus, Denmark
 "The New Ones from Leningrad, "
 Kulterhuset, Stockholm
1989 "Selected Works from the Frederick R.
 Weisman Art Foundation," Wight Art
 Gallery, University of California, Los
 Angeles
 "Afrika and Timur Novikov," Tate
 Gallery, Liverpool
 First North American Exhibition of the
 Friends of Mayakovsky Club, Paul
 Judelson Arts, New York
 "The Green Show," Exit Art, New York
1990 Designs sets and costumes for "August
 Pace," Merce Cunningham Dance
 Company, for performances at The City
 Center, New York, and the University of
 California, Berkeley

"The Work of Art in the Age of
Perestroika," Phyllis Kind Gallery, New
York
"In the Soviet Union and Beyond,"
Stedelijk Museum, Amsterdam
"Le Territore de l'Art," State Russian
Museum, Leningrad; Institute des
Hautes Études en Arts Plastiques, Paris
"Donalddestruction," one-man exhibi-
tion, Lenin Museum, Leningrad
1990–91 "Between Spring and Summer: Soviet
 Conceptual Art in the Era of Late
 Communism," Tacoma Art Museum,
 Tacoma; Institute of Contemporary Art,
 Boston; Des Moines Art Center, Des
 Moines
1991 "Soviet Contemporary Art: From Thaw
 to Perestroika," Setagaya Art Museum,
 Tokyo
 "The Idea of the Individual Body in the
 Era of Late Totalitarianism: Recent Art
 from Leningrad," Museo de Arte
 Moderno, Mexico City
 "Donalddestruction," one-man exhibi-
 tion, The Power Plant, Toronto;
 Clocktower Gallery, New York
1992 "Afrika," one-man exhibition, Fisher
 Gallery, University of Southern
 California, Los Angeles
1993 "Art Meets Ads," 25th anniversary,
 Dusseldorf Kunsthalle, Dusseldorf
 "Art Against AIDS,"group exhibition,
 Venice Biennale, Venice; Guggenheim
 Museum, Soho, New York
 "Method," Pori Museum of Modern Art,
 Finland
 "After Perestroika: Kitchenmaids or
 Stateswomen?" Centre d'Art
 Contemporain, Montreal
1994–95 One-man exhibition, Espace Montjoie,
 Paris
 "Cocido Crudo," Museo National Centro
 de Arte Reina Solia, Madrid
1995 "Afrika: Aphasia of Representation,"
 one-man exhibition, Austrian Museum
 of Applied Arts, Vienna
 "Kabinet," Stedelijk Museum,
 Amsterdam
 "Binationale: Soviet Art Around 1990,"
 Dusseldorf Kunsthalle, Dusseldorf; The
 Israel Museum, Jerusalem
 "Donalddestruction," one-man exhibi-
 tion, Fisher Gallery, University of
 Southern California, Los Angeles;
 Queens Museum of Art, Flushing

Olga Bulgakova

1951	Born, Moscow
1969	Graduates, Moscow Secondary Art School
1975	Graduates, Surikov Art Institute
1976	Becomes member of USSR Artists Union
	"The Self-Portrait in Russian and Soviet Art," group exhibition, Tretiakov Gallery, Moscow
1979	International Exhibition of Young Painters, group exhibition, Artists' Union Hall, Sofia, awarded Grand Prize
1980	International Triennial of Contemporary Art, group exhibition, Belgrade
1981	"Three Moscow Artists," Kuznetski Most, Moscow
1982	Venice Biennale, Russian Pavillion, Venice
1983	"Aspekte Sowjetischer Kunst der Gegenwart: Sammlung Ludwig" (travels extensively throughout Europe and The Netherlands)
1984	"Contemporary Soviet Artists," The Netherlands
1985	"Tradition and Search," Grand Palais, Paris (travels extensively throughtout Germany)
1986	"Six Soviet Painters," Latvia and Estonia, USSR
1987	"The Moscow Studio," East Berlin
	"Eight Moscow Painters," Dublin
1988	Exhibition of Ludwig Collection, Ludwig Museum, Cologne
	International Exhibition of Soviet Art, Bologna
1989	"Moscow Artists in London," Riverside Artists' Group, London
1990	"Twenty-Six Leningrad and Moscow Artists," Manezh Exhibition Hall, Leningrad
	"The Quest for Self-Expression: Painting in Moscow and Leningrad, 1965–1990," Columbus Museum of Art (travels extensively throughout the U.S. in 1991)
1991	"Liquid, Fragile, Gaseous," Florence
1993	"Dream Discovers the Nature of Things," Tretiakov Gallery, Moscow
1994	"Moscow Artists: New View," Kuznetski Most, Moscow

Andrei Filippov

1959	Born, Petropavlovsk-Komchatsky currently resides in Moscow)
1982	Graduates, Stage Design, School of Academic Artists Theater, Moscow

1983	"Aptart en Plein Air," Moscow
	"Aptart Beyond the Fence," Moscow
1986	"Aptart," New Museum of Contemporary Art, New York
1987	17th Youth Exhibition, House of Artists, Kuznetski Most, Moscow
	First Exhibition of Avant-Gardists' Club, Exhibition Hall at Avtozavodskaya, Moscow
	"Visual Artistic Culture," Hermitage Association, Moscow
1988	"Labyrinth," Palace of Youth, Moscow
	Second Exhibition of Avant-Gardists' Club, Exhibition Hall at Avtozavodskaya, Moscow
	"20 Years," Hermitage Association, Moscow
1989	"Mosca: Terza Roma," Sala I Gallery, Rome
	"Momentaufnahme: Junge Kunst aus Moskau," Altes Stadtmuseum, Munster
	"Expensive Art," Palace of Youth, Moscow
	Third Exhibition of Avant-Gardists' Club, Exhibition Hall at Avtozavodskaya, Moscow
1990	Group exhibition, Gallery Eva Poll, Berlin
	Group exhibition, Krings-Ernst Gallery, Cologne
	Stedelijk Museum, Amsterdam
	Tsaritsino Museum, Tokyo
	"Schizo-China," Moscow
	"Other Art," Tretiakov Gallery, Moscow
1990–91	"Between Spring and Summer: Soviet Conceptual Art in the Era of Late Communism," Tacoma Art Museum, Tacoma; Institute of Contemporary Art, Boston; Des Moines Art Center, Des Moines
1991	"Mama Cosmos," Moscow
	"Russian/Israeli Binational Exhibition," Dusseldorf; Jerusalem; Moscow
	"The Esthetic Experience," Kuskovo, Moscow
	"Novocento," Central Artists House, Moscow
1992	"Topography," L Gallery, Moscow
	"Questions in Art," L Gallery, Moscow
	Istanbul Biennale, Istanbul
1993	"Provisory Address for Russian Art," Muse de la Poste, Paris
	"Field of Action," Krings-Ernst Gallery, Cologne
	"Ausfling," L Gallery, Moscow
1994	"Works on Paper: Selections from the Kolodzei Collection," City Arts Center, Oklahoma City

Oleg Golocii

1965	Born, Dnepropetrovsk (lived in Kiev)
1984	Graduates, Dnepropetrovsky Art School
	Studies, Kiev Art College
1987	"Country of Soviets," Kiev
	First Youth of the Country Exhibition, Kiev
1988	"Pictorial Ukraine," Kiev
	Second Youth Exhibition, Manezh Exhibition Hall, Moscow
	Becomes member of Ukrainian Artists' Union
1989	Second Youth of the Country Exhibition, Kiev
	Exhibits in Mars Gallery, Moscow
1990	"Three Generations of Ukrainian Art," Kiev/Berlin
	"Babylon," Palace of Youth, Moscow
	Republican Spring Art Exhibition, Kiev
	"Between Modernism and Postmodernism," Galeria Zacheta, Warsaw
	"New Ukrainian Painting," Budapest
	"New Figurations," Odessa
	Exhibition of Ukrainian Artists, (travels throughout Sweden)
1991	One-man exhibition, Ridzhina Art Gallery, Moscow
1992	One-man exhibition, Gallery 369, Edinburgh
	"Post-Anaesthetization," Kunsthalle, Munich
1993	One-man exhibition, Guelman Gallery, Moscow
	"Angels over Ukraine," Edinburgh Festival of Arts, Edinburgh
1993	Dies, Kiev
1994	One-man exhibition, Ridzhina Gallery, Moscow (posthumous)
	"Free Zone," Museum of Modern Art, Odessa, Ukraine (posthumous)

Andrei Karpov

1959	Born, Tula, USSR (currently resides in Moscow)
1986	Graduates, Moscow Physical-Technical Institute
1989	"Furmanny Lane 1," Warsaw
	"Dialogue," Paris
1990	"Furmanny Lane 2," Zurich
	"Between the Postmodernism and Trans-avant-garde," Bratislava-Krakow
	"Three Artists from Russia," Stockholm
	"Meeting," Davidson Galleries, Seattle
1991	Storm Collection, London

127

1992 VI International Exhibition, Los Angeles
"Diaspora," Moscow

1993 "Stairs (Ladders)," Central Artists
House, Moscow

Ivan Kolesnikov

1954 Born, Rostov-on-Don (currently resides
in Moscow)

1970–74 Studies, Rostov-on-Don Art School
(graduates, 1974)

1977–82 Studies, Stroganov Art Institute,
Moscow (graduates, 1982)

1989 Annual Exhibition of Young Artists,
Palace of Youth, Moscow
"Ados," Moscow

1990 "Ganza Art '90," Deventer, USSR
"Youth," one-man exhibition, Magazine
Gallery, Moscow

1991 "Passed Ways," Milan
ART MIF, International Art Fair, Moscow

1993 "Four Artists from Russia," Palm
Springs, California

1994 "Distortions," one-man exhibition,
Central Artists House, Moscow

Valerii Koshliakov

1962 Born, Salsk, USSR (currently resides in
Moscow)

1985 Graduates, Rostov-on-Don Higher Art
School

1990 "For Civilized Leisure," Moscow
"Waiting for Respite," Moscow
"Great Magicians of Painting," Moscow

1991 "Aesthetic Experiments," Kuskovo,
Moscow
Group exhibition, Gallery 369,
Edinburgh
Center for Contemporary Art Inaugural
Exhibition, Moscow
"Under the Sky of Italy," Tallinn, Estonia
"Night in Venice," one-man exhibition,
Guelman Gallery, Moscow

1992 One-man exhibition, Palace of Youth,
Moscow
"Parthenon," one-man exhibition,
Trochprudnii Gallery, Moscow

1993 One-man exhibition, Guelman Gallery,
Moscow
"About the Motherland," one-man exhi-
bition, Trochprudnii Gallery, Moscow
"Large Order," one-man exhibition,
La Base, Paris
"On the Ruins of the Totalitarian
Epoch," State Russian Museum,
St. Petersburg

Georgii Litichevskii

1956 Born, Dnepropetrovsk, Ukraine (cur-
rently resides in Moscow)

1974–79 Studies, Moscow State University

1989 "Kinderstern," Domberger Gallery,
Stuttgart
"Mosca: Terza Roma," Sala I Gallery,
Rome
"Dialogue," Boris Vian Cultural Center,
Les Ullis, France
Art Kites Project, International
Participation

1990 "Transformation: The Legacy of
Authority," Camden Art Centre, London
"Aufbruch," Domberger Gallery,
Stuttgart
Co-founds Boli group with Farid
Bogdalov
"White Action," with Boli group,
Moscow
"Mothers of Pinocchio," with Boli group,
Moscow
"Russian Ravioli," with Boli group,
Moscow
Moscow Zoo Exhibition, with Boli
group, Moscow

1991 "Exercises in Aesthetics," with Boli
group, Kuskovo Museum, Moscow
"Moscow, Leningrad, Tblissi," Museum
of Angers, France
"Milano-Poesia," with Boli group, Milan
"New Neon Cube," with Boli group,
Kuskovo Museum, Moscow
"Crossing Boundaries," The Lab, San
Francisco
"Chistaprudnii Boulevard," Galleria XXI,
Madrid
One-man exhibition, Culture Club of
Physicists, Moscow

1992 Third International Istanbul Biennale,
exhibition of "Trojan Horse," with Boli
group, Istanbul
"Cubopressure," with Boli group,
Moscow; San Francisco; Milan; Pistoia
"Molteplici Culture," Convento di S.
Egidio, Rome

1993 "Exchange," Moscow
"Identity-Selfhood," Museum of
Contemporary Art, Helsinki
"Orangerie and Surroundings," one-man
exhibition, Velta Gallery, Moscow

1994 "Holzkololde," Gallery IFA, Bonn
"Victory and Defeat," Obscuri Viri
Gallery, Moscow
"Multifaced Pinocchio," one-man
exhibition, Gallery Wilhelmina,
Amsterdam

"Muses, Mices and Graces," one-man
exhibition, Obscuri Viri Gallery,
Moscow
"Works on Paper: Selections from the
Kolodzei Collection," City Arts Center,
Oklahoma City

Badri Lomsianidze

1961 Born, Kutaisi, Georgia, USSR (currently
resides in St. Petersburg)

1981 Moves to Leningrad

1989 Graduates, Muhinskoa Institute,
Leningrad

1990 Group exhibition, International
Academy of Arts and Cinema

1991 Group exhibition, Information and
Culture Center, Berlin

1992–93 Group exhibitions, Pushkin Square 10,
St. Petersburg

Bogdan Mamonov

1964 Born, Moscow

1987 Graduates, Moscow Polygraphic
Institute

1987–90 Collaborates with Panayev &
Skabichevsk and 5+1 groups, Moscow

1988 "Until 33," Palace of Youth, Moscow
"Eidos," Palace of Youth, Moscow
"5+1," Kuznetski Most, Moscow

1989 "Glasnost in Zunzdorf," Alten Kloster
Gallery, Cologne

1990 "5+1," Borghaus, Aachen
"Young Soviet Art," Kassel

1991 One-man exhibition, Alten Kloster
Gallery, Cologne
"Agaspher," Sadovniki Gallery, Moscow
"After the War with the Aborigines,"
Museum of Revolution, Moscow

1992 "In Search of a Vanished Masterpiece,"
one-man exhibition, Guelman Gallery,
Moscow
"Six Unknowns," Guelman Gallery,
Moscow
"Triad," Leipzig

1993 "Portrait of an Unknown Man," one-man
exhibition, Guelman Gallery, Moscow
"7th Congress of Russian Parliament
Exhibition," Central Artists House,
Moscow
"New Areas for Art," Museum of Visual
Art, Krasnoyarsk, USSR
Group exhibition, Hamburg Art
Museum, Hamburg
"Nostalgia," American Trade Center,
Moscow

1994 "Conformists," Central Artists House, Moscow

"If I Would Be a Jew," Central Artists House, Moscow

"Bad News from Russia," Central Artists House, Moscow

Andrei Medvedev

1960 Born, Moscow

1979 Graduates, 1905 Art School, Moscow

1988 "Labyrinth," Palace of Youth, Moscow

"Soviet Art," Helsinki

"The Russian Avant-Garde," Brussels

One-man exhibition, Moscow

1989 "Eros and Erotica," Moscow

One-man exhibition, Moscow

One-man exhibition, Gilda Gallery, Lisbon

1990 One-man exhibition, Guelman Gallery, Moscow

"5+1: Artists from Moscow," Lisbon

"Babylon," Palace of Youth, Moscow

One-man exhibition, Marc Sanvil Gallery, Brussels

Group exhibition, Moscow Art Gallery, Toronto

Group exhibition, Fine Gold Gallery, Atlanta

"Russian and Soviet Art," Tokyo

"Ideal Project for the Soviet Art Market," Central Artists House, Moscow

1991 Group exhibition, Guelman Gallery, Moscow

One-man exhibition, Guelman Gallery, Moscow

1993 "Nostalgia," American Trade Center, Moscow

Sergei Mironenko

1959 Born, Moscow

1978 "Experiment," Malaya Gruzinskaya Street Gallery

Numerous exhibitions with the Mukhomor group, Moscow and environs

1981 Graduates, Faculty of Stage Management, Moscow Arts Theater Institute

1982 First Aptart Exhibiton, Aptart Gallery, Moscow

1983 "Aptart en Plein Air," Aptart Open-Air Exhibition, Moscow

"Come Yesterday and You'll Be First," City Without Walls, Newark

1984 One-man exhibition, Center for Contemporary Russian Art, New Jersey

1985 "Aptart in Tribeca," Washington Project for the Arts, Washington, D.C.

1986 "Aptart," New Museum of Contemporary Art, New York

"Laboratory," Exhibition of Young Artists, Kuznetski Most, Moscow

1987 "Retrospective Exhibition of Moscow Unofficial Artists: 1957–1987," Hermitage Association, Moscow

"Art and Hygiene," Avant-Gardists' Club, Exhibition Hall at Vostochnaya St., Moscow

1988 "Labyrinth," Palace of Youth, Moscow

Group exhibition, Kuznetski Most, Moscow

"New Soviet Art," Imatra, Finland

"New Russians," Palace of Culture and Science, Warsaw

"Eidos," Palace of Youth, Moscow

1989 "Momentaufnahme: Junge Kunst aus Moskau," Altes Stadtmuseum, Munster

"Seven Artists from Moscow," Palace of Expositions, Budapest

"USSR Today: Soviet Art from the Ludwig Collection," Contemporary Art Museum, St. Etien, France (travels throughout Europe in 1990)

One-man exhibition, First Gallery, Moscow

"Agitpunkt," one-man exhibition, Gallery Pelin, Helsinki

Receives Award of Distinction from the Pollock-Krasner Foundation, New York

1990 "A Century of Modernism," one-man exhibition, Krings-Ernst Gallery, Cologne

"Made in Furmanny," City Gallery, Melbourne; Stedelijk Museum, Amsterdam

"Erosion," Amos Anderson Museum, Helsinki

"Towards the Object," Tsaritsino Museum, Tokyo; Stedelijk Museum, Amsterdam

"End of a Century," National Gallery, Reykjavik

"No Vacio: Contemporary Russian Artists," Auditorio de Galicia, Santiago de Compostela, Spain

"In the Rooms," Palace of Exhibitions, Bratislava

One-man exhibition, ERCC, Marseille

1990-91 "Between Spring and Summer: Soviet Conceptual Art in the Era of Late Communism," Tacoma Art Museum, Tacoma; Institute of Contemporary Art, Boston; Des Moines Art Center, Des Moines

1992 "To Moscow, to Moscow," Central Artists House, Moscow; Tranenpalast, Berlin

"Sots Art," Lenin Museum, Moscow

"A Group Show," one-man exhibition, First Gallery, Moscow

1993 "Rinako Collection of Contemporary Art," Exhibition Hall, Casse des Depots et Consignations, Paris

"Five Artists from the Aidan Gallery," Central Artists House, Moscow

"Art as Power, Power as Art," Central Artists House, Moscow

The International Print Exhibition, Machida, Tokyo

1994 The Ludwig Collection, Aachen

"Artist Instead of Art: Jump into the Emptiness," Central Artists House

"Works on Paper: Selections from the Kolodzei Collection," City Arts Center, Oklahoma City

Natalia Nesterova

1944 Born, Moscow

1955–62 Studies, Moscow Secondary Art School

1966–86 Participates in more than 100 All Union, Republican, and Moscow exhibitions

1968 Graduates, Surikov Institute, Moscow

1969 Becomes member of USSR Artists Union, Moscow

1981–89 Exhibits extensively throughout Europe via international art fairs and group exhibitions

1982–85 Exhibits yearly in Ludwig Collection, Cologne

1986 Group exhibition, Kunstlerhaus Bethanien, West Berlin

1987 Paris FIAC '87, Paris

1988 One-woman exhibition, Nakhamkin Gallery, New York

1989 "Natalia Nesterova and Lazar Gadaev," Manezh Exhibition Hall, Moscow

1989 "London/Moscow," group exhibition of 20 artists from both cities, London

1990 One-woman exhibition, Hal Bromm Gallery, New York

"Contemporary Soviet Art," Aldrich Museum of Contemporary Art, Ridgefield

"The Quest for Self-Expression: Painting in Moscow and Leningrad, 1965–1990," Columbus Museum of Art (travels extensively throughout the U.S. in 1991)

1991 One-woman exhibition, Hal Bromm Gallery, New York

One-woman exhibition, Maya Polsky Gallery, Chicago

1992	One-woman exhibition, Musée des Beaux Arts, Montreal
1993	One-woman exhibition, Maya Polsky Gallery, Chicago
	Group exhibition, Museum of Contemporary Art, Lausanne
	Group exhibition, Central Artists House, Moscow
	"Eight Artists from Moscow," Bishop Gallery, Stuttgart
	"Classic-4," Belgian Biennale, Belgium
1994	"Four Russian Messengers: Carnival or Drama?" Baltimore
	One-woman exhibition, Hal Bromm Gallery, New York
	Group exhibition, A-Z Gallery, Moscow
	"Contemporary Art," ITAR TASS, Moscow
	Exhibits, Art Chicago '94, Chicago

Igor Nezhivoy

1967	Born, Moscow
1983–87	Studies, Moscow Energy University
1989	"Furmanny Lane 1," Warsaw
1990	"Furmanny Lane 2," Lausanne
	"Russian Contemporary Art," Vienna
1991	Group exhibition, Storm Gallery, London
1993	International Biennale, Belgium
	Group exhibition, Navy Arsenal, Amalfi
	ART MIF, International Art Fair, Moscow
	Two-man exhibition, Virginia Center for Creative Arts, Richmond (artist in residence)
	Group exhibition, Caiart Gallery, Palm Springs, California

Timur Novikov

1958	Born, Leningrad (currently resides in St. Petersburg)
1967	First exhibition, Children's Drawings, New Delhi
1972–75	Takes art courses at State Russian Museum, Leningrad
1977	First exhibits paintings with Chronicle group, Leningrad
	Becomes member of Letopis group, Leningrad
1979	"Exhibition of the 10," Folk Art Theater, Leningrad
1980	"Of Time and Myself," one-man exhibition, Leningrad
1981	"Artists from Leningrad," Tartu University, Tartu

1982	Society of Experimental Art Exhibitions, Palace of Youth, Kirov Palace of Culture, Leningrad
	Organizes ASSA group and Popular Mechanics rock group with other artists
	First exhibition of the New Artists group, Kirov Palace of Culture, Leningrad
1983	One-man exhibition, Library of the Academy of Sciences of the USSR, Leningrad
	Group exhibition of Leningrad Arts, Palace of Culture, Chkalov State Farm, Crimea
1984	"Facets of the Portrait," Kirov Palace of Culture, Leningrad
1985	"Your Praise I Sing, O Land of Leningrad," Central Exhibition Hall, Leningrad
	Rock Festival Exhibition, The Rock Club, Leningrad
1986	"The Art of Leningrad Painters," Kadriong Palace, Tallinn
	"New Artists," 17th Youth Exhibition, Central Artists House, Moscow
	Co-founds the Friends of Mayakovsky Club, Leningrad, with the artist Afrika
1987	"New Artists," The Coliseum, Leningrad
	"New Artists," presented at the premiere of the film ASSA
1988	"Red Wave," Jerry Soloman Gallery, Los Angeles
	"80 Talents of the New Russian Avant-Garde," Art Atrium, Stockholm
	"Da Da Mayakovsky," Dionysus Gallery, Rotterdam
	"The New Artists," Raab Gallery, Berlin
	"40 Years of Leningrad Non-Official Art," Exhibition Pavilion on the Harbour, Leningrad
	"The Leningrad Show: 21 Artists from the Fellowship of Experimental Art," Memorial Union Art Gallery, University of California, Davis
	"The Friendship of Art," Palace of Youth, Leningrad
1989	"Selected Works from the Frederick R. Weisman Art Foundation," Wight Art Gallery, University of California, Los Angeles
	"Afrika and Timur Novikov," Tate Gallery, Liverpool
	First North American Exhibition of the Friends of Mayakovsky Club, Paul Judelson Arts, New York
	"The Green Show," Exit Art, New York
	"Four Artists from Leningrad," Helsinki

1990	"The Work of Art in the Age of Perestroika," Phyllis Kind Gallery, New York
	"In the Soviet Union and Beyond," Stedelijk Museum, Amsterdam
	"Le Territore de l'Art," State Russian Museum, Leningrad; Institute des Hautes Études en Arts Plastiques, Paris
	"Between Spring and Summer: Soviet Conceptual Art in the Era of Late Communism," Tacoma Art Museum, Tacoma; Institute of Contemporary Art, Boston; Des Moines Art Center, Des Moines
	"The Work of Art in the Age of Perestroika," Phyllis Kind Gallery, New York
	"The New from Petersburg: Young Artists from Leningrad," Muczarnok Exhibition Hall, Budapest
1991	"Soviet Contemporary Art: From Thaw to Perestroika," Setagaya Art Museum, Tokyo
	"The Idea of the Individual Body in the Era of Late Totalitarianism: Recent Art from Leningrad," Museo de Arte Moderno, Mexico City
	"Binationale: Soviet Art Around 1990," Dusseldorf Kunsthalle, Dusseldorf; The Israel Museum, Jerusalem
	"Neo-Academism," Lenin Museum, Leningrad
	"Gagarian Party," Cosmos Museum, Moscow
	"Les Allumees Nantes-Leningrad '91," Nantes
1992	"Russian Resurgence: Recent Works by Timur Novikov," one-man exhibition, Center for the Fine Arts, Miami
	"Binationale: Soviet Art Around 1990," Central Artists House, Moscow
	"Modern Collection," Diaghilev Center, St. Petersburg
	One-man exhibition, Museum of Ethnography, St. Petersburg
	"Russian Resurgence: Recent Works by Timur Novikov," one-man exhibition, Center for the Fine Arts, Miami
1993	"A Few Fey Things," White Columns, New York
	Founds Classical Art Workshop, St. Petersburg
	"After Perestroika: Kitchenmaids or Stateswomen?" Centre d'Art Contemporain, Montreal
	"History of Unofficial Art," City Museum, St. Petersburg
	"Mayakovsky, 100 Years," State Russian Museum, St. Petersburg

"Oscar Wilde's Adventures," one-man exhibition, Paul Judelson Arts, New York

"Timur Novikov," one-man exhibition, Stedelijk Museum, Amsterdam; Dusseldorf Kunsthalle, Dusseldorf; Frederick R. Weisman Museum of Art, Los Angeles; Pepperdine University, Malibu; Espace Montjoie, Paris

1994 "The Swan Song of German Romanticism: Recent Works by Timur Novikov," Kunstlerhaus Bethanien, Berlin

"Renaissance and Resistance," curator and participant, Marble Palace, State Russian Museum, St. Petersburg

One-man exhibition, Phyllis Kind Gallery, New York

"The Animated Space, Interferences 1," one-man exhibition, Museum of Modern Art, Vienna

Ivan Olasuk

1961 Born, small unnamed village, Georgia, USSR (currently resides in St. Petersburg)

1981 Moves to Odessa, studies art privately

1989 All Union Artists Exhibition, Central Artists House, Moscow

1990 Moves to St. Petersburg

1991–93 Group exhibitions at Pushkin Square 10, St. Petersburg

Aleksandr Roitburd

1961 Born, Odessa, Ukraine (currently resides in Kiev)

1983 Graduates, Department of Painting and Drawing, Teacher's Training College, Odessa

1987 "Youth of the Country," Kiev; Moscow

1988 "Sovieart," Kiev

1989 Second Youth Exhibition, Manezh Exhibition Hall, Moscow

"Exhibition of Four Artists," Odessa International Exhibition of Young Artists from Socialist Countries, Moscow

All Union Artists Exhibition, Central Artists House, Moscow

"Ukrainian Wave," Moscow

1990 "Babylon," Palace of Youth, Moscow

"Ukrainian Art: 1960–1980," Odessa

"After Modernism," Odessa Museum of Art, Odessa

ART MIF, International Art Fair, Moscow

"Soviet Artists," Art Base Gallery, Singapore

"Young Artists from the USSR," Warsaw

One-man exhibition, Guelman Gallery, Moscow

1992 One-man exhibition, Guelman Gallery, Moscow

Arsen Savadov & Georgii Senchenko

1962 Both born, Kiev (currently reside in Kiev)

1987 Graduate, Kiev Institute of Fine Arts

Republic Youth Exhibition, Kiev

"Youth of the Country," All Union Exhibition, Palace of Youth, Moscow

Group exhibition, FIAC, Paris

1988 ARCO International Art Fair, Madrid

All Union Youth Exhibition, Palace of Youth, Moscow

1989 Exhibition of Young Artists from Socialist Countries, Moscow

1990 "Young Artists of the Ukraine," Budapest

1991 Presentation, Center for Contemporary Art, Moscow

"Aesthetic Experiments," Kuskovo Museum, Moscow

Two-man exhibition, Guelman Gallery, Moscow

ART MIF 2 , Second International Art Fair, Moscow

Two-man exhibition, Central Artists House, Moscow

1992 "Shtil," Kiev

"Works: 1990–1991," two-man exhibition, Berman - E.N. Gallery, New York

"Postanaesthesia," two-man exhibition, Munich

1993 Group Ukrainian Exhibition, Edinburgh

Eduard Shteinberg

1937 Born, Moscow

No formal training, studies with his father, Arcadi Shteinberg, and the artists Boris Sveshnikov and Oskar Rabin

1961 Exhibition of Young Artists, Moscow

1963 Dostoevski Museum, Moscow

1965 Institute for Atomic Energy, Moscow

1967 Becomes member of the Graphics Union, Moscow

Becomes member of Sretensky Boulevard group of unofficial artists including Ilya Kabakov and Erik Bulatov

Participates in numerous exhibitions including the Druzhba Club

"Compositions of the Enthusiasts: Exhibition of 12," Moscow

1968 Exhibition of Young Artists, Kuznetski Most, Moscow

1970–90 Exhibits extensively throughout Europe

1985 First one-man exhibition outside of USSR, Bochum Museum, Kunstsammlung

1987 First one-man exhibition in USSR, Hermitage Association, Moscow

1988 "Eduard Shteinberg: Paintings," Galerie Claude Bernard, Paris

1989 "Contemporary Soviet Art," Hotel de Ville, Strasbourg

"Eduard Shteinberg: From the Landscape Series," Cooperative Pictures, Moscow

"Eduard Shteinberg: Paintings," Claude Bernard Gallery, New York

Roland Shalamberidze (Shala)

1958 Born, Kutaisi, Georgia, USSR (currently resides in St. Petersburg)

Studies writing and music at private school in Kutaisi

1973 Begins painting

1985 First one-man exhibition, Kutaisi Gallery, Kutaisi

1989 Moves to Leningrad

1990 "Letter for Sperrow," 10/10 Gallery, Leningrad

One-man exhibition, Orfey Gallery, Panama

"X.W.T.E.S.," Association of Experimental Art, Leningrad

"All Soviet Biennale," Leningrad

1991 "On the Content of Drama, Kafka Slant," New Solianka Exhibition Hall, Moscow

One-man exhibition, Academy of Modern Cinema, Paris

1992 Group exhibition, Palace of Arts, Bonn

"The Pink Elephant on the Ball," one-man exhibition, Tampere, Finland

"Ten Petersburg Cats," Central Exhibition Hall, St. Petersburg

Second All Soviet Biennale, St. Petersburg

Group exhibition, Pankou Gallery, Berlin

1993 Group exhibition, Akhmatova Museum, St. Petersburg

Group exhibition, T&I Gallery, Berlin

One-man exhibition, Nikolaevsky Palace, St. Petersburg

"Pointing with the Car," C.N.B.,
St. Petersburg

1994 "Cake Wall," Gallery 21, St. Petersburg
 "Blind Painting," Gallery 120,
 St. Petersburg

Sergei Sherstiuk

1951 Born, Moscow
1964–70 Studies graphics at Art Institute of Kiev
1974–79 Studies theory of art and art history,
 Moscow State University
1980 Becomes member of USSR Artists
 Union
1980 12th Exhibition of Young Artists,
 Moscow
1980–85 Member of Group of Six, Moscow
1981 13th Exhibition of Young Artists,
 Moscow
1982 "Contemporary Art from the USSR,"
 Gorky Gallery, Paris
 "Three Super Realists," Pushchino,
 USSR
 14th Exhibition of Young Artists,
 Moscow
 All Union Exhibition of Young Artists,
 Moscow
1983 Exhibition of Moscow Super Realists,
 Moscow
 15th Exhibition of Young Artists,
 Moscow
1984 "Creative Artists from the USSR and
 Czechoslovakia," Yalta
 "Russian and Soviet Art," Dusseldorf
 Kunsthalle, Dusseldorf (travels through-
 out Germany in 1985)
1985 17th Exhibition of Young Artists,
 Moscow
 "Work of Young Soviet Artists:
 Dedicated to the 12th International
 Youth Festival," Exhibition Hall, USSR
 Union of Artists, Moscow
1986 "Contemporary Russian Art from the
 Collection of Norton and Nancy
 Dodge," Addison Gallery, Phillips
 Academy, Andover, Massachusetts
1987 18th Exhibition of Young Artists,
 Moscow
 "War and Peace Through the Eyes of
 Artists," Hermitage Museum,
 Leningrad
 "Contemporary Soviet Art: The Will to
 Self-Expression in a Conformist
 Society," Kennesaw College Art
 Gallery, Marietta, Georgia
 "Post Socialist Realism: The New Soviet
 Reality," Firebird Gallery, Alexandria,
 Virginia

1988 "Artwork of the Soviet Union,"
 Guernsey's, New York
 "Glasnost Scene: New Art from the
 Soviet Union and Bulgaria," Trammell
 Crow Center, Dallas, Texas
 "Post Socialist Realism: The New Soviet
 Reality," Montgomery Fine Arts Center
 Gallery, St. Mary's College, St. Mary's
 City, Maryland
 "War and Peace Through The Eyes of
 Artists," Hamburg; Munich; Moscow
1990–91 "The Quest for Self-Expression: Painting
 in Moscow and Leningrad, 1965-1990,"
 Columbus Museum of Art, Columbus
 (travels extensively throughout the
 U.S. in 1991)
1992 "The Russian Roulette,"one-man exhibi-
 tion, Maya Polsky Gallery, Chicago,
 Illinois
1993 One-man exhibition, Velta Gallery,
 Moscow
 "The Dream of Four," Central Artists
 House, Moscow
1994 Group exhibition, Mars Gallery, Moscow

Vasilii Shulzhenko

1949 Born, Moscow
 Studies, Moscow Artistic High School
 and Moscow Polygraphic Institute
1990 "50 años de Arte Sovietica Catalonia,"
 Catalonia
 "Arte Moderna Sovietica," Rome
 One-man exhibition, Maya Polsky
 Gallery, Chicago
1991 "Golden Brush," Moscow
 Group exhibition, Galerie Karass,
 Haarlem, The Netherlands
 Group exhibition, Mars Gallery, Moscow
 "Moments in the Same Story: Vasilii
 Shulzhenko and Seymour Rosofsky,"
 Maya Polsky Gallery, Chicago
1992 ART MIF, International Art Fair,
 Moscow
 Chicago International Art Exposition,
 Special Focus Exhibition
 "New Russia–New Art," St. Francis
 College, Ft. Wayne, Indiana
1993 "Montage: Art and Image," Haarlem,
 The Netherlands
 Chicago International Art Fair
 One-man exhibition, Maya Polsky
 Gallery, Chicago
 ART MIF, International Art Fair,
 Moscow
1994 Chicago International Art Fair
1995 One-man exhibition, Maya Polsky
 Gallery, Chicago

Aleksandr Sigutin

1959 Born, Rostov-on-Don (currently resides
 in Moscow)
1979 Graduates, Graphics and Architecture
 Faculty, Rostov Pedagogic Institute
1988 Exhibition of work by "Teachers and
 Students" from Pedagogical Institute,
 Manezh Exhibition Hall, Moscow
1990 Moves to Moscow
1991 "Before and After," Palace of Youth,
 Moscow
 "Form and Content," Trochprudnii
 Gallery, Moscow
 "Mummy Space," Propeller Gallery,
 Moscow
 One-man exhibition, Trochprudnii
 Gallery, Moscow
1992 "Questions in Art," L Gallery, Moscow
 "Calm/Style," Kiev
 "Still Life," Velta Gallery, Moscow
 "Landscape," A-3 Gallery, Moscow
 "Moscow Romanticism," Central Artists
 House, Moscow
 "Hierarchy in Art," Trochprudnii Gallery,
 Moscow
 "The Artist and the Book,"
 Avtozavodskaya, Moscow
1993 "In the Memory of a Great Teacher,"
 Trochprudnii Gallery, Moscow
 One-man exhibition, Trochprudnii
 Gallery, Moscow

Avdei Ter-Oganian

1961 Born, Rostov-on-Don (currently resides
 in Moscow)
1978–81 Studies, Rostov-on-Don College of Art
1980 One-man exhibition, Youth Center,
 Rostov-on-Don
1981 One-man exhibition, Psychiatric
 Hospital, Rostov-on-Don
1988 "Italy Has the Shape of a Boot," Central
 Exhibition Hall, Rostov-on-Don
1989 Moves to Moscow
1990 "Great Magicians of Painting,"
 Peresvetov Lane Exhibition Hall,
 Moscow
1990 "Between Postmodernism and Avant-
 Gardism," Warsaw
1991 Establishes Trochprudnii Gallery,
 Moscow. Organizes and participates in
 more than 36 exhibitions there
 between 1991 and 1993, including
 numerous one-man exhibitions
1992 "Questions of Art," L Gallery, Moscow
 "Calm/Style," Kiev
 "Still Life," Velta Gallery, Moscow

"Landscape," A-3 Gallery, Moscow
"Moscow Romanticism," Central Artists House, Moscow
"Waste," State Center of Contemporary Art, Moscow
"Political Art," Central Artists House, Moscow
"Still Life with Candlestick," one-man exhibition, Guelman Gallery, Moscow

1993 "Some Problems of Restoration of Works of Contemporary Art," one-man exhibition, Trochprudnii Gallery
"Devoted to VII Congress of People's Seputies," Guelman Gallery, Moscow
"In the Tower, in the Gallery, on the Street," Stuki Gallery, Lodz, Poland

1994 "Fluchpunkt Moskau," Ludwig Collection, Aachen
"Moscow Artists: A New View," Kuznetski Most, Moscow
"Artists Instead of Art: Jump into the Emptiness," Central Artists House, Moscow
"May Exhibition," Kuznetski Most Moscow
"Reproduction: Mon Amour," Contemporary Art Center, Moscow

Inessa Topolskii

1966 Born, Moscow
1988 All Union Youth Exhibition, Central Exhibition Hall, Moscow
1989 Graduates, Moscow Art College, Graphics Department
Works in association with husband, Dimitri, on majority of projects
"Inexpensive Art or Small Creatures," First Gallery, Moscow
1991 "Kunst Ral," Amsterdam
Numerous group exhibitions at the Trochprudnii Gallery, Moscow
1992 "Questions of Art," L Gallery, Moscow
1993 "Art Hamburg," International Art Fair, Aidan Gallery, Hamburg
ART MIF, International Art Fair, Moscow, Aidan Gallery, Moscow
Aidan Gallery Exhibition, Central Artists House, Moscow
1994 "Renaissance et Resistance," State Russian Museum, St. Petersburg

Natasha Turnova

1957 Born, Kabul, Afghanistan (currently resides in Moscow)
1983 Graduates, Stroganov Art School, Moscow

1985 Group exhibition, Malaya Gruzinskaya Street Gallery, Moscow
1986 17th Young Artists Exhibition, Kuznetski Most, Moscow
1987 Retrospective Exhibition of Moscow Artists, Hermitage Association, Moscow
"The Youth of the Country," Palace of Youth, Moscow
"The Young Monumentalists of Moscow," Central Artists House, Moscow
Interart-87, Lodz, Poland
1988 Interart-88, Lodz, Poland
"Geometry in the Art," Kashitskoe Shocse Exhibition Hall, Moscow
"Culture of the Holiday," Moscow
"I-Creative Association," Moscow
18th Young Artists' Exhibition, Manezh Exhibition Hall, Moscow
"Labyrinth," Palace of Youth, Moscow
ARCO International Art Fair, Madrid, Spain
1989 "Hermitage in Holland," The Netherlands
"Before 33," Palace of Youth, Moscow
"Eidos," Palace of Youth, Moscow
"Glasnost," Stuttgart
"Soviet Avantguard," Mitisk, USSR
"Moscow to London," Thumb Gallery, Moscow
"Transformation: The Legacy of Authority," Camden Art Centre, London
"The New Reality," Milan; Ravenna, Italy
"Red and White," Warsaw; Amsterdam
"Collection-89," Helsinki
1990 "Fractures," Luxembourg
Russian Collection, Museum of Contemporary Art, Tampere, Finland
"Modern Soviet Paintings," Melbourne
"Logic of Paradox," Palace of Youth, Moscow
"From Sociorealism to Sots Art," VDNH, Moscow
One-woman exhibition, Regina Gallery, Moscow
"Traditions of Russian Painting," Moscow; Minsk
1991 "Washington–Moscow," Tretiakov Gallery, Moscow
Two-person exhibition with Vasilii Kravorua, Regina Gallery, Moscow
"Moscow to London II," Jill George Gallery, London
"A Chicken Is No Bird," Amsterdam; Arnhem, The Netherlands; Antwerp, Belgium
ART MIF, International Art Fair , Moscow

1992 "Second Culture," Central Artists House, Moscow
"From Playstocen to Golosen," Museum of Paleontology, Moscow
Group exhibition, Melikhov Gallery, Moscow

Andrei Yakhnin

1966 Born, Moscow
1983–88 Studies, Moscow Institute of Architecture (graduates, 1988)
1986 Becomes member of Champions of the World group, Moscow
1987–89 Participates in Champions of the World exhibitions
Participates in First Avant-Garde Exhibition, Moscow
1988 "Labyrinth," Palace of Youth, Moscow
"Sandunovsky Baths Show," Avant-Gardists' Club, Moscow
"Rauschenberg to Us, We to Rauschenberg," First Gallery, Moscow
1989 Becomes member of the Graphics Union, Moscow
"History of Furmanny Lane," Basel
"Art Junction," Nizza, France
"Champions of the World," Bernard Felli Gallery, Paris
"Dialogue," Center of Boris Vian, Paris
1990 Venice Biennale, Russian Pavilion
"Champions of the World," Strasbourg
"Face to Face," one-man exhibition, First Gallery, Moscow
1990–91 "The Quest for Self-Expression: Painting in Moscow and Leningrad, 1965–1990," Columbus Museum of Art, Columbus (travels extensively throughout the U.S. in 1991)
1991 "Moscow Contemporary Art," Seibo Art Forum, Tokyo
"Champions of the World," Pori Museum of Modern Art, Finland
1992 "Mosca a Mosca," Museum of Contemporary Art, Bologna
"Short Stories," one-man exhibition, Gallery Sprovieri, Rome
1993 "Art Hamburg," Gallery Sprovieri, Hamburg
ART MIF, International Art Fair, Aidan Gallery, Moscow
"White Nights," Yakut Gallery, Moscow
"Fermat Theorem," one-man exhibition, Pori Museum of Modern Art, Finland
1994 "Le Saut Dans Le Vide," Central Artists House, Moscow
"Second Chapter," one-man exhibition, Institute of Contemporary Art, Moscow

133

Acknowledgments

For the assistance of many individuals, both in the early stages of assembling the Keesee Collection and later in the preparation of the exhibition *New Russian Art,* we would like to extend thanks. For his advice and enthusiasm in the initiation and developmental stages of the Christian Keesee Project for Contemporary Russian Art, we would like to thank Christopher Youngs, former Director of the Oklahoma City Art Museum.

For the benefit of their experience in the field, we want to acknowledge the followiing art dealers and gallery owners; Maya Polsky of the Maya Polsky Gallery, Chicago; Paul Judelson, Paul Judelson Arts, New York; Nathan Berman, Berman-E.N. Gallery, New York, and Marat Guelman, Guelman Gallery, Moscow.

Both Tania and Natasha Kolodzei, of the Kolodzei Foundation, Moscow, were of immeasurable assistance to us throughout this project. Their understanding of contemporary Russian art, their association with numerous artists and their willingness to share their knowledge helped us to achieve our goals. We are also grateful to them for their attention to the many details of assembling the Artists' Chronologies for this catalog, not a small task to say the least.

While in Russia, we required a "support staff." For their valued help, we would like to thank Vladimir Bodrov who became our driver, bodyguard and friend. Through all of our trips, he proved dependable and resourceful, two qualities necessary for operating in Russia. Our interpreter, Alexi Sinodov guided us through the intricacies of communication, accompanying us to nearly all of the 100 artists studios we visited and providing assistance with correspondance after our return. We are most grateful to Victor Litvinov, Studio Kvadrat, Moscow for arranging for storage and shipment of all artwork. Negotiating the Russian import/export and customs system proved to be one aspect of the project which required the greatest expertise and patience.

The job of stretching, mounting, framing and in some cases restoring, works of art, fell to Dennis Johnson, Oklahoma City. His conscientiousness and expertise in handling the art once it arrived in Oklahoma and his further attention to the details of preparing it for travel is much appreciated.

For their guidence in promoting and circulating *New Russian Art* we would like to acknowledge the staff of Curatorial Assistance Inc., Los Angeles. Special thanks goes to Graham Howe, Gwen Hill and Robin Clark for their continued support and attention to the myriad details involved in overseeing the circulation of the exhibition. For her consultation and direction in readying the accompanying catalog for production, we would like to thank Karen Bowers of Curatorial Assistance.

For contribution of installation materials we would like to thank Steve Bruno, United Mechanical, Inc., Oklahoma City.

We would like to thank Andrew Solomon for his Introduction to this catalog and for his consultation and advice throughout various stages of the project. Donald Kuspit who also contributed an essay to the catalog looked at the art we acquired and discussed its form and content in regards of the ongoing collection.

To all of the above individuals, we are grateful and share in the success of *New Russian Art.*